AMERICAN PORTRAITS

100 COUNTRIES

Photographs by
Michael Clinton

Glitterati
INCORPORATED

Dedication

For several hundred years, people from around the world have come to what has become the United States of America. This book is dedicated to their courage, strength, and passion to seek a better life for themselves and future generations of their families.

First published in the United States
of America in 2009 by

Glitterati Incorporated
225 Central Park West, Suite 305
New York, New York 10024
www.GlitteratiIncorporated.com
Telephone: 212 362 9119
glitteratimedia@gmail.com for inquiries

First edition, 2009

Design: Sarah Morgan Karp/smk-design.com

Library of Congress Cataloging-in-Publication data is available from the publisher.

Hardcover edition ISBN 13: 978-0-9822669-1-5

Printed and bound in China by Hong Kong Graphics and Printing Ltd.
10 9 8 7 6 5 4 3 2 1

Contents

Within this book are ninety-three faces that will stick with you long after you've finished flipping through the pages. Photographer Michael Clinton began his project fueled by a passion for photography and profound love of country. He set out to find Americans from all stations, whose bloodlines can be traced back to one hundred individual countries.

The research often began with a simple request, a query delivered in the unlikeliest of places: a bustling restaurant, an elevator ascending a pre-war Manhattan apartment building, or a dinner party where conversation predictably centered on the obvious and the polite.

Clinton cut through all that. "Tell me your story," he would say to people he'd just met. The responses delighted him. The narratives were harrowing, sometimes heroic and always filled with hope. So began his documentation of the people willing to share their story and their image . . . wearing a smile as proudly as the history they brought to the surface. His extraordinary mosaic was coming to life.

In my years as a network journalist, the most frequent question I hear is, "Which assignment stands out the most?" The answer is never the story, always the people. It is the faces I remember best.

As the crisis of Hurricane Katrina unfolded, I saw the diabetic woman who sought shelter without her medicine in the Convention Center. As she pleaded for help, she collapsed before our camera. An off-duty nurse begged for insulin from the crowd and aided the woman who was floating between consciousness and coma. On that day, it was the woman in despair and the nurse so determined to save her that stayed with me. Two faces I will not forget.

I was in Northern Israel, as Hezbollah rockets rained down indiscriminately on small towns and villages. There was a doctor, whose task it was to shop for organs among family members who had just died. One Israeli man immediately said yes, saying his late brother would have wanted this. The doctor harvested the dead man's eyes, and placed them in a patient who happened to be Arab. After the surgery, the Arab embraced the grieving Israeli brother and thanked him for the gift of sight. Two faces I will remember always.

And this year, as the economy upends so many Americans, a seventeen-year-old boy named Chris invited me to his family's Los Angeles apartment. His parents could no longer afford the rent. As the teenager revealed an empty refrigerator, Chris assured me it wouldn't always be like this, "after the storm, the sun always comes out." He's right. Sunshine follows every storm. His is another face that sticks with me.

Each of these faces tested by challenge offer so much hope. What photographer Michael Clinton captures in *American Portraits* is the expectation that an uncertain future in one's homeland could be improved upon here. Individual spirit and determination could shape an entire family's fate.

Clinton tells the story of Linda Jackson. Several generations of her family came to America from Sierra Leone. They were transplanted African slaves who married both Cherokee and Shinnecock Indians first living in South Carolina. Imagine then the rich journey that brought them to Brooklyn, New York.

Clinton photographed Tamara Levinson, whose maternal grandparents fled Nazi Germany for Argentina, and whose parents landed in America when Tamara was six years old. They hoped to provide for their daughter the American dream about which they heard so much. Levinson would later represent the United States in gymnastics in the 1992 Olympic Games. Seventeen years later, Clinton's photograph perfectly captures an American who proudly displays her individual spirit with tattoos and a tank top.

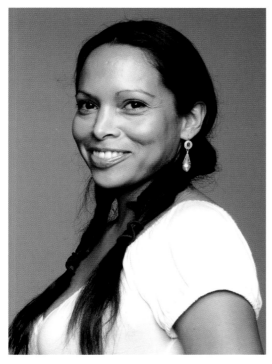 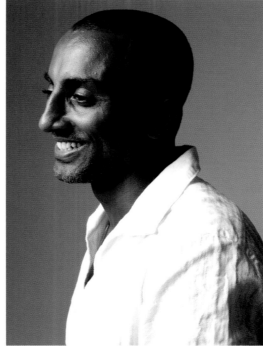 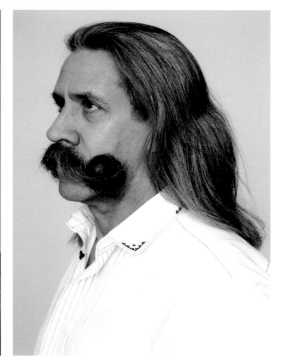

There is Tiffany Bui Rothman, whose pregnant mother escaped Saigon as it fell to the North Vietnamese in April 1975. Rothman describes to Clinton the journey she and her two siblings took before calling a refugee camp in Arkansas home.

And there's Debra Shriver, whose forefather, an English farmer, came to Virginia in 1657, three hundred years before she was born. Generations of her family ultimately landed in Alabama where she was raised. Her ancestors fought in the Civil War and later in the battle for civil rights from

the African-American neighborhoods of southern Alabama. We learn of her story in the same year this country inaugurated its first African-American president.

With every photograph, Clinton reveals a different portrait of the American dream, each with its own travails and triumphs, each with a journey motivated by hope for a better life for the generations that will follow.

Michael Clinton confessed he considered the inclusion of celebrities in this book, but ultimately decided against it, believ-

ing every one of these ninety-three faces deserved their own moment to shine. Their mile-wide smiles and their journeys that span even further, will leave their mark on you long past the final page.

David Muir
ABC News
New York

introduction

There is something about America—something that conjures a smile from a child in the streets of Antanarivo, Madagascar, when he hears that you have traveled from there to visit his country and he wants to know if you know Barack Obama; when an old woman in a market in Split, Croatia tells you that her brother lives in Columbus, Ohio, and that her dream is to go there to visit him; or when a young lawyer in Montevideo, Uruguay dreams to begin a new life in America and actually makes the move.

In my travels to nearly 120 countries around the world, I've never met anyone who has not been intrigued or hasn't dreamed about coming to America . . . to visit, to work, or to start over again. Even in the places where there is political tension with America, the people have a curiosity. They too want to know about my country.

Although I am a second-generation American on my father's side, I never knew my immigrant grandparents, who came from Ireland and England and met on Manhattan's Upper West Side. And while I'm a third generation Lithuanian on my mother's side, our family was too Americanized to have any real sense of the "old country."

Like many Americans of my generation, I grew up in the American century, when what became known as the American way of life

was perfected. It was when movie images depicted suburban order and prosperity, creature comforts, the freedom of your own automobile, and the belief that you could become whatever you wanted to be in life. When I traveled the world, people would inevitably ask me, "What's it like in New York? In California? In Las Vegas?" America is a place where everyone comes from somewhere else. We aren't a people, who like my friend, Sam Farah, a Syrian-American, can trace his family back over one thousand years. We are a nation of immigrants, regardless of whether our forefathers came on the *Mayflower*, through Ellis Island, or arrived at Los Angeles International Airport. And we are still arriving—from Asia, from Latin America, from Europe, from just about every country in the world.

The concept for this book came during a trip to the Baltics, to Estonia, Latvia, and a search for my own roots in Lithuania. I had been taking photographs for my book, *Global Faces*, when I saw a woman in her eighties who could have been my grandmother's sister. And while my grandmother had died twenty years earlier, and had never stepped from American soil, here was a woman on the streets of Vilnius, who had the same bloodlines as me, and could have been someone in my own American family. And so, when I returned, I decided to talk

to Americans about their stories. I learned about how my friend, Haideh Hirmand's family fled Iran for Los Angeles, after the fall of the Shah; how Renee Dominique had a mix of Afghani, Irish and Trinidadian blood; and how my Cambodian friend, Mayanna Prak, had a family history that was worthy of a screenplay! What intrigued me is that while multiculturism seems to be the new face of America, we have always been a nation of different kinds of people.

Once upon a time in America, for a Greek to marry an Irishman was its own version of multi-culti. Or if an Italian Catholic married a Russian Jew, it was considered exotic and even in some circles, taboo. We are a nation of many bloodlines. And some of us have a mix of many of them, while others still have only one. But it is always changing. Haideh is of one hundred percent Iranian background, but she is married to a Frenchman. The mix continues.

My goal was to find Americans whose bloodlines all added up to one hundred countries of origin. It didn't matter how many, I just wanted to identify one hundred unique countries of origin in my search. As I began my quest, putting out the word to family and friends, what was most astonishing was how so many people seemed to know so many people from so many backgrounds. My friend, Penny Lieberman, knew

someone who had Albanian and Montenegro roots, while Chris Shirley had a friend who had Greek and Cypriot roots. Freeda Farah found me an Iraqi and a Jordanian, and I learned that my buddy, Russ Theriot, was Norwegian, French, Canadian and Cajun. For over a year, whenever I met anyone, I would inevitably ask them, "So, what's your ethnic background?" and often say, thank you, but I have found someone with your bloodline. I'd be in a business meeting and turn to a client, like Andrea Luhtanen, to learn that she was Finnish and Slovenian. My response? "I need you!"

At restaurants, on airplanes or at the movies, I would look at people who had a unique face and approach them with, "Excuse me, can I ask you a question?" Most people loved telling me their story, and what struck me was the richness of each of them. They were tales of tragedies and triumphs, dreams and hope. It made me proud to be an American, as I reflected on how our forefathers had the courage and determination to move forward to a place that brought us all to a shared experience of the pursuit of life, liberty and happiness.

These are the portraits of many of my fellow Americans, who I met in my search. They each have distinctive stories to tell, and they all reflect collectively who we are as a people.

We are Caucasian and African American and Asian, and a mix of Hispanic, Indian and many more bloodlines, and becoming more so every day.

Who knows what America will look like in one hundred years? For this experiment that was started over 230 years ago, we will continue to be a nation of people with fascinating stories of where we all once came from and how we are living and working as a people to keep the American idea alive. Perhaps no one exemplifies this more than President Obama, who reminded us of this, as he became our leader.

If you'd like to tell us your story, write to us at *americanportraits100countries.com* to share with us your American story and the portrait of your life.

Michael Clinton
New York, New York

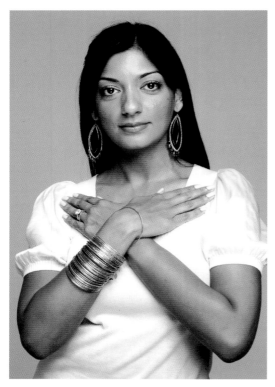 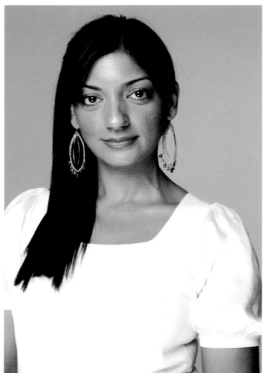

Ansari

My parents were born in India, but moved to Pakistan, when the two countries separated. They ultimately moved to London, each to study for a PhD. It is in London that I and my two siblings were born. I came to America when I was twelve years old, studied biochemistry in college, but ultimately pursued my dream to work in the fashion and publishing industries.

Sarah Ansari/Ad Sales Executive/Pakistan

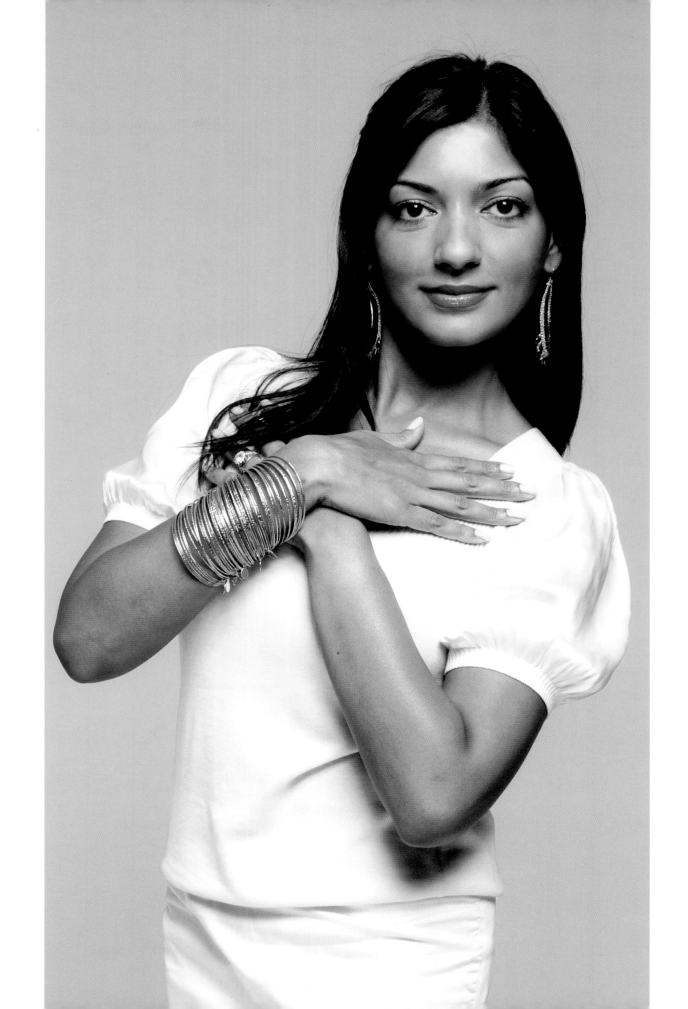

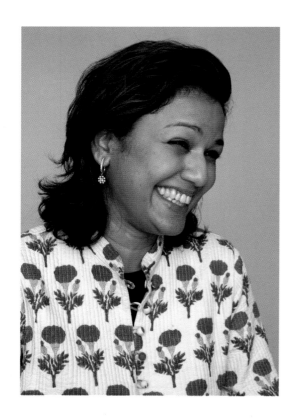

Rahman

In Bangladesh, I was destined to be somebody's daughter, somebody's wife. So I came to the United States to re-invent myself. I set foot on Princeton's campus at age eighteen, filled with excitement. In hindsight, I should have been scared of leaving behind all that was familiar. But I cherished the chance to define myself while still maintaining a core Asian tradition. I aspire to be strong and independent, like my grandmother.

Anika Rahman/Lawyer/Bangladesh

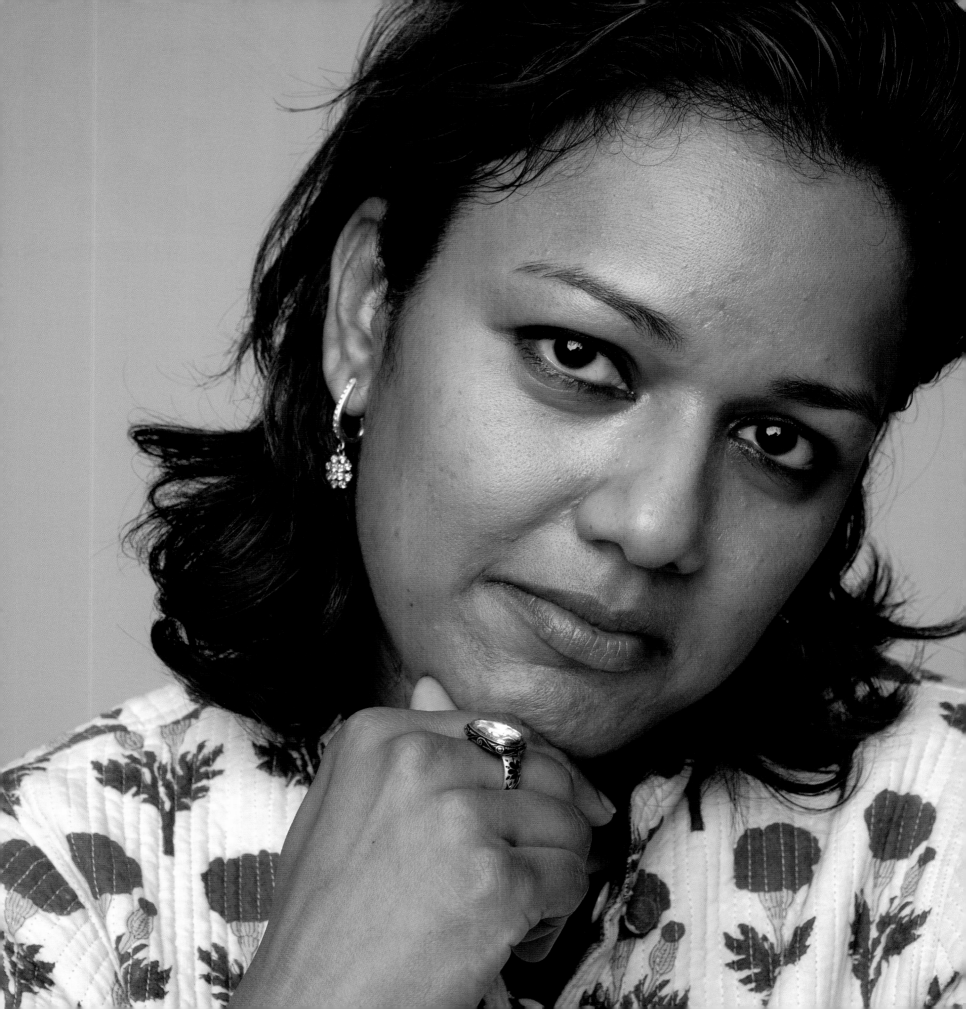

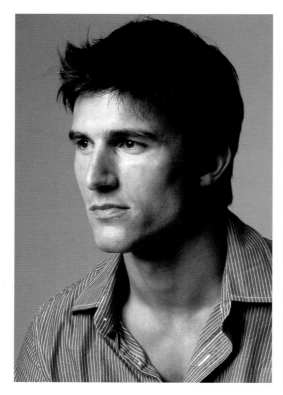 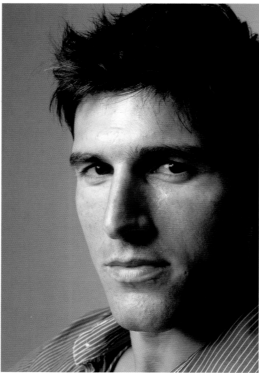

Theriot

Both my French and Norwegian forefathers first moved to Nova Scotia, but ultimately moved to Louisiana for work in the oil production business. My mother's ancestors moved directly to Louisiana from France and it was there that the French and Cajun bloodlines intermingled. My entire family still lives in Louisiana, and I'm the first one to leave the state to seek a different way of American life.

Russ Theriot/Personal Trainer/Cajun, Canada, France, Norway

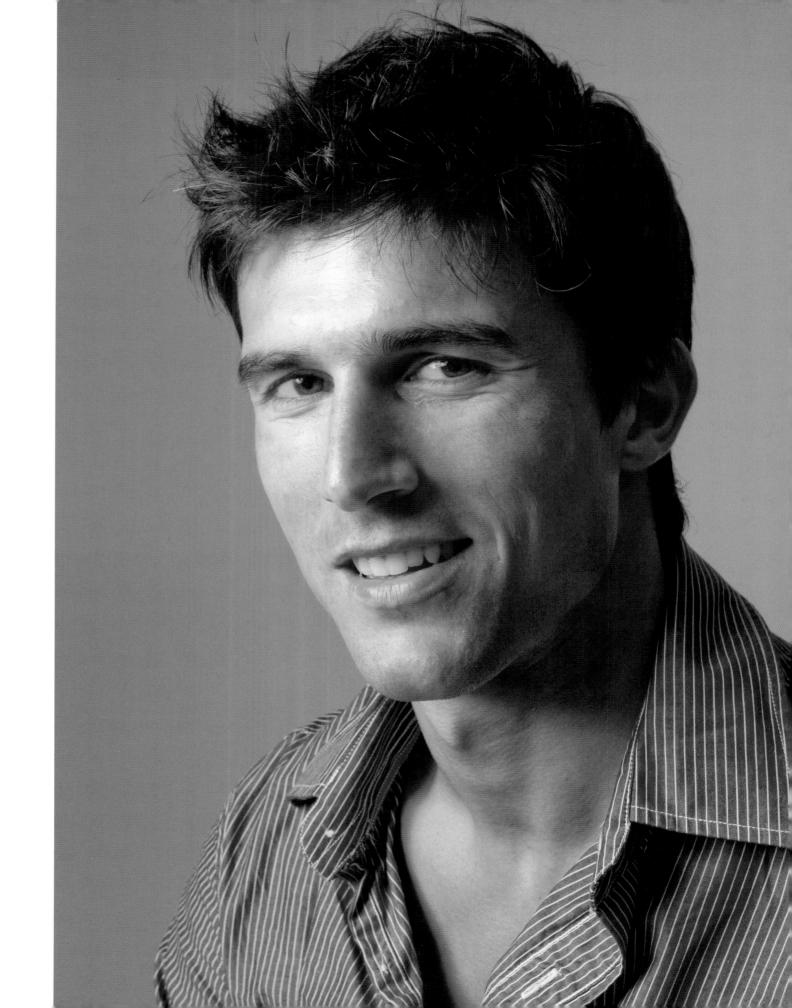

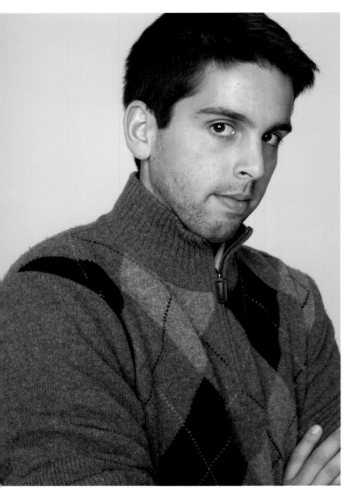 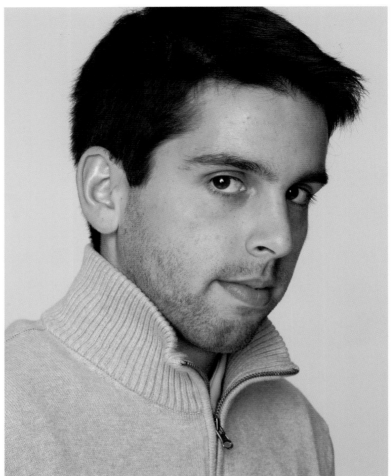

Brunk

My father's family were German Mennonite immigrants who moved to Virginia in the 1700s, and along the way, our family bloodlines mixed with French Huguenots, Quakers, and Cherokee Indians. My mother's family origi- nated in Yemen six hundred years ago, moving to India and then Sri Lanka in the late 1800s. As a young woman of eighteen, my mother left Sri Lanka to be educated in America, met my father at university, and stayed to start what has become her American family.

Adam Brunk/Teacher/Cherokee, France, Germany, Sri Lanka, Switzerland, Yemen

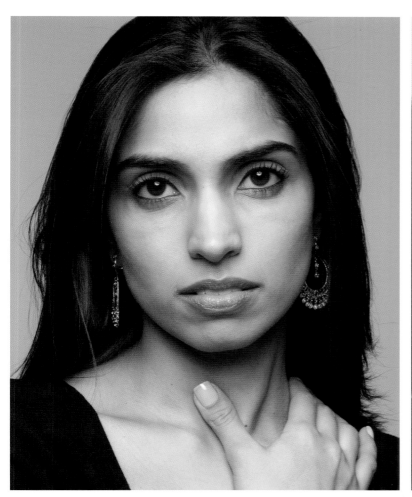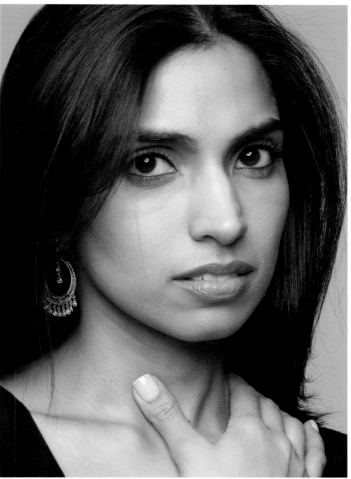

Both of my parents came to Ohio State for graduate school in the late 1960s and met there. After my mother received a PhD in mathematics and my father received a Masters in engineering and an MBA, they decided to stay in the United States, where they ultimately raised me and my sister, Manisha Sethi. Our family believed in education. My sister has an art degree from the Art Academy of Cincinnati and I graduated from Georgetown and a masters program at Columbia. America gave us the opportunity for great higher education.

Ritu Ahuja/Retail Executive/India

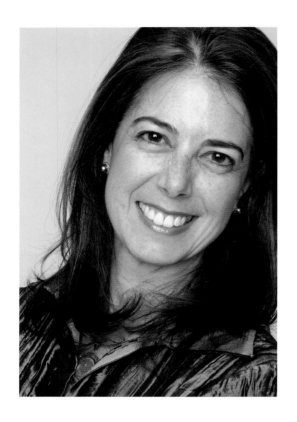

My father was born in Baghdad in a family that had deep roots in Iraqi government, and we were related to the first prime minister of Iraq. He came to America to train as an urologist, where he met my mother, who was born in England to Irish parents. I was born in America, and earned a BA and MA in near eastern literature and language, before earning an MBA to work in management.

Laila Marie Al-Askari/Director of Administration and Finance/Iraq, Ireland

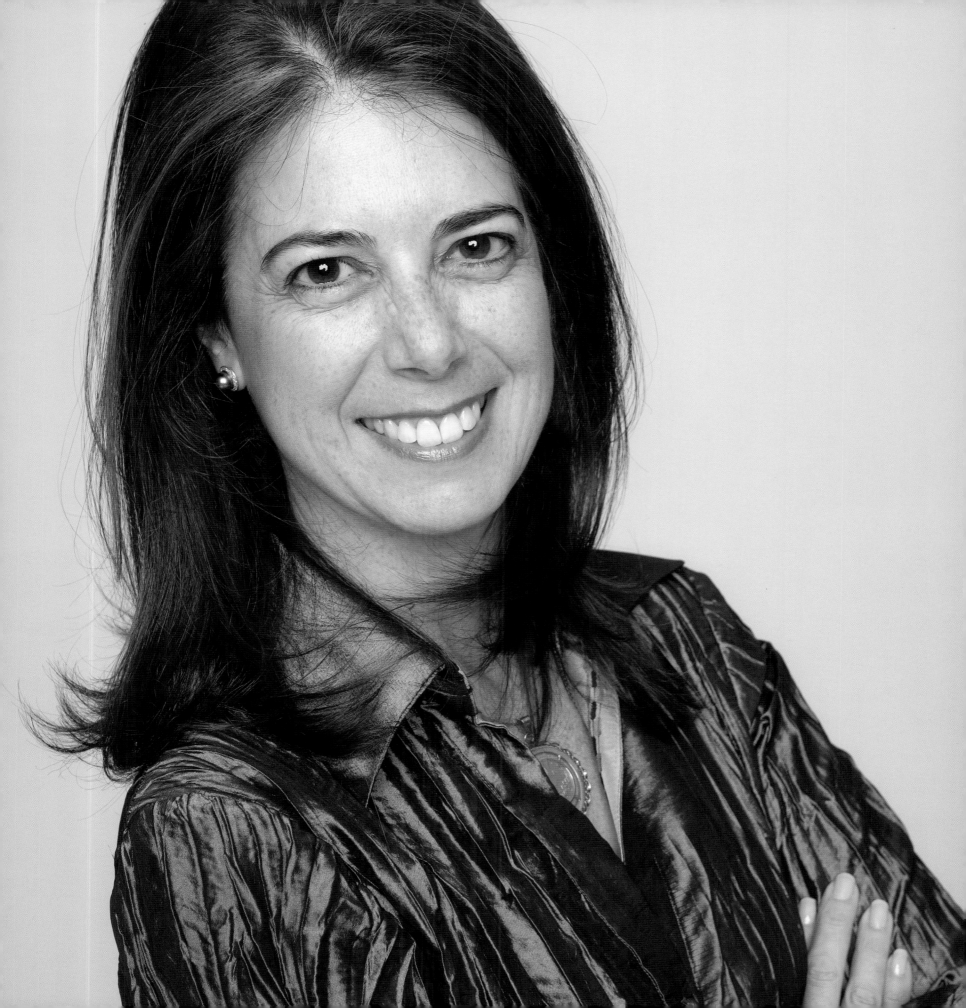

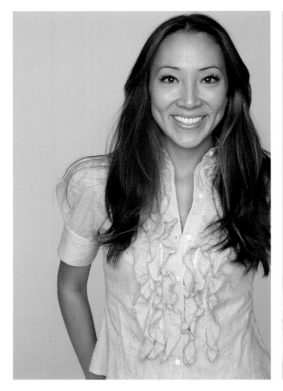 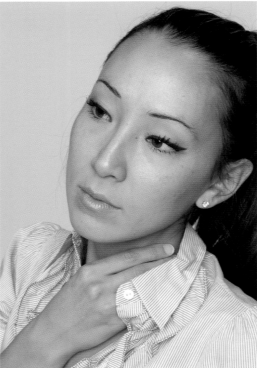

Shayakhmetova

My great-grandfather on my father's side was the first ethnic Kazakh to be President of Kazakhstan, during Stalin's rule over the Soviet Union. My parents came to the United States to work for the United Nations in the 1970s. I was born in NYC and attended the International School. Aside from English, I am fluent in Russian and French.

Karima Shayakhmetova/Publicist, Translator/Kazakhstan, Tatar

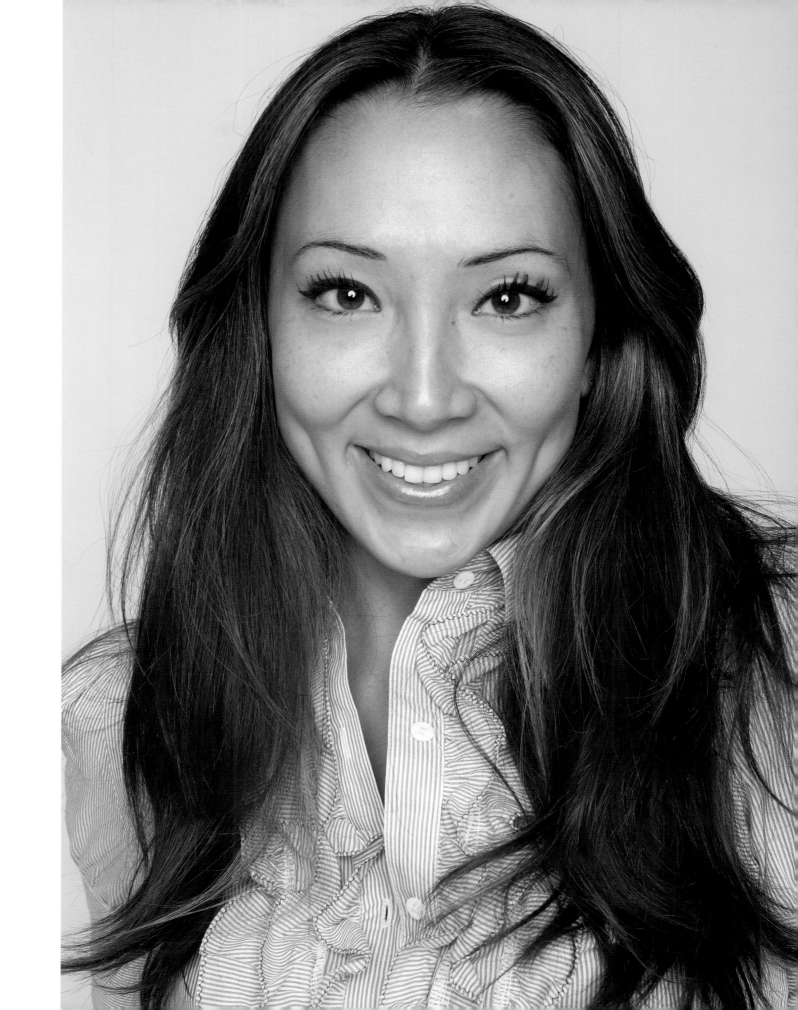

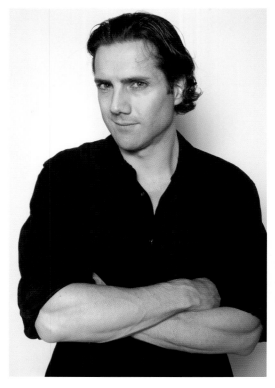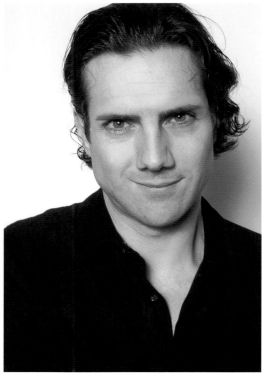

My parents are fourth-generation Uruguayans, and I first came to America to study business after graduating from law school in Uruguay. I returned to live in my home country, but realized that America and all that it represented was the dream that I wanted to pursue. It is here that I am happy and where I want to realize my professional and personal ambitions.

Juan Paysse/Private Banker/England, France, Netherlands, Uruguay

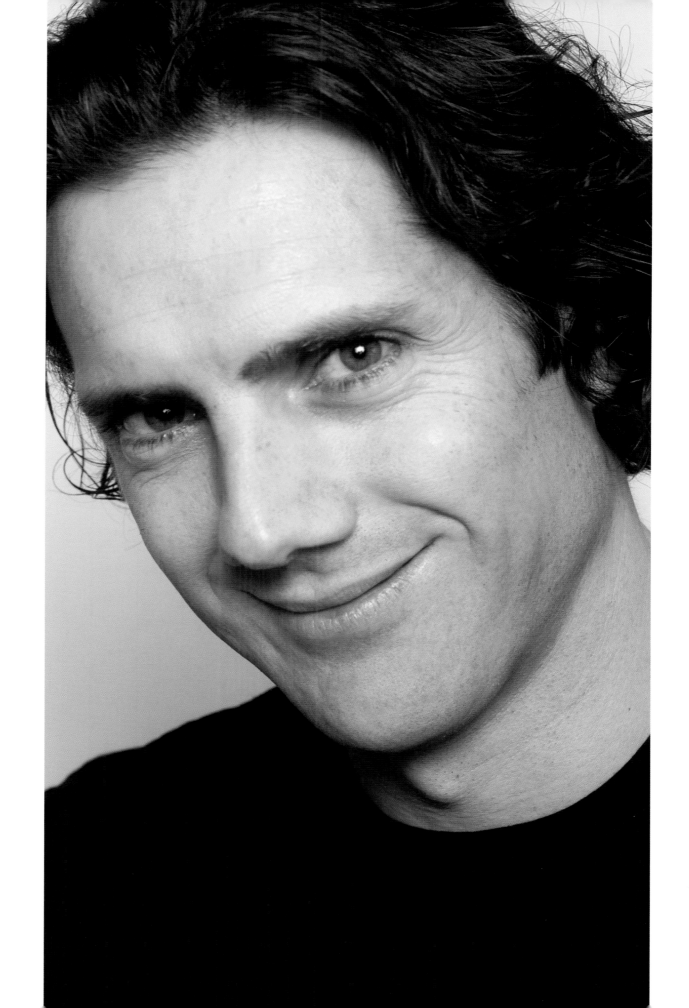

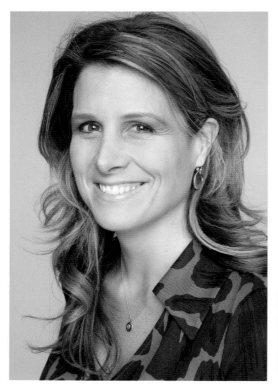 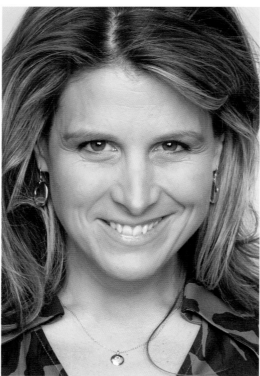

My name, de Bonvoisin, translates to "good neighbor" in French. I was born in New York, but I have lived in Paris, Brussels, Hong Kong and London, for work and school. My great-grandfather was the head of the Resistance in Belgium during the Great War, and my mother's family originally came from the Dordogne Valley in the Perigord in southwest France. While I have worked in the corporate world, my passion has been to become an entrepreneur, which I have done by establishing *first30days.com*.

Ariane de Bonvoisin/Entrepreneur, Author/Belgium, France

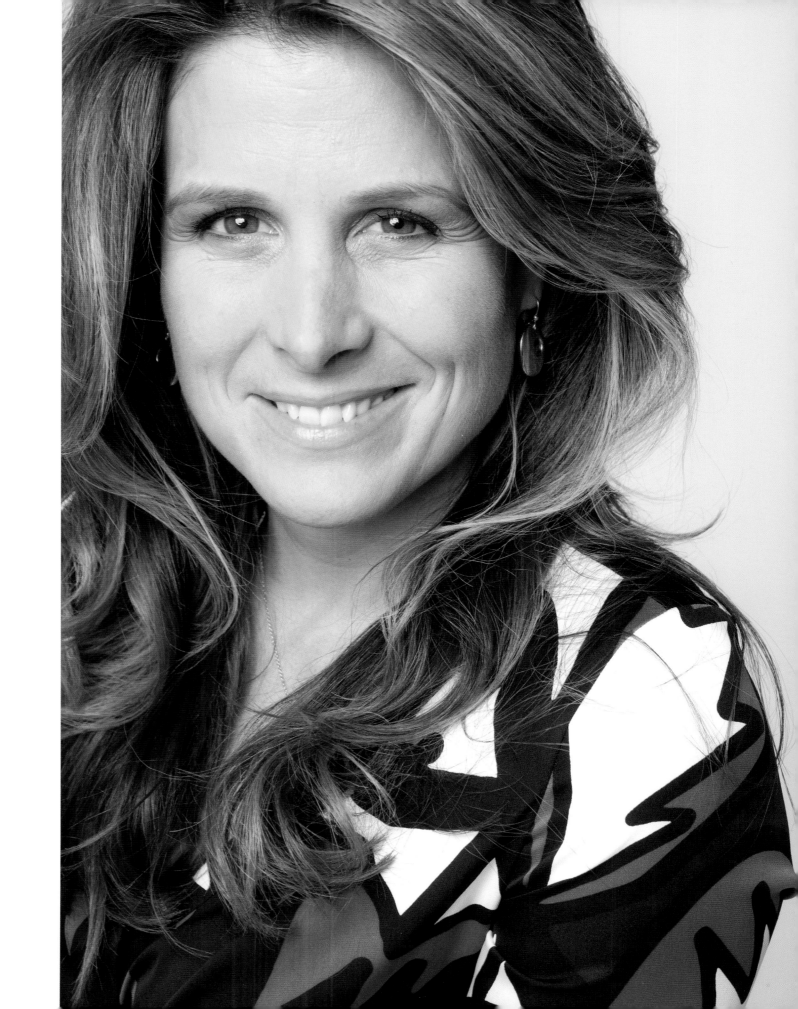

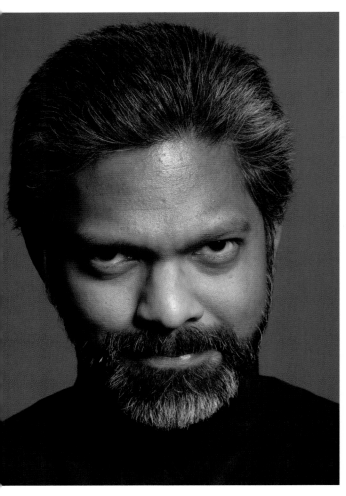
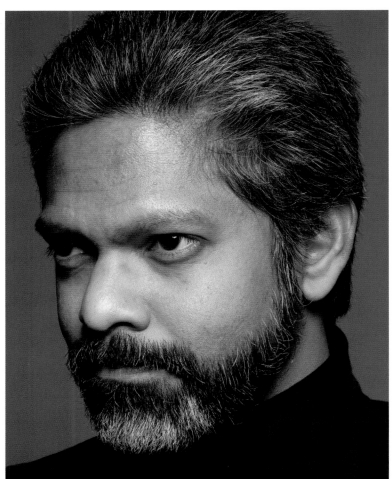

My great-grandparents moved from India and China to the East Indies, in pursuit of work. Both of my parents, a teacher and an accountant, were second generation Trinidadians, but I decided to pursue life as an American, moving here to develop my own dream. It was here that I met my wife, who has a Dominican background. Our goal is to continue to live the American Dream.

Curtis Darbasie/Financial Analyst/Arawak, China, Trinidad

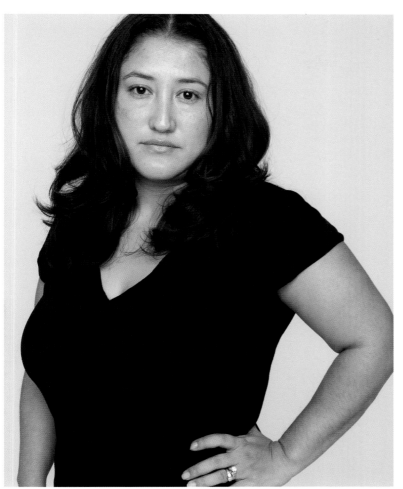
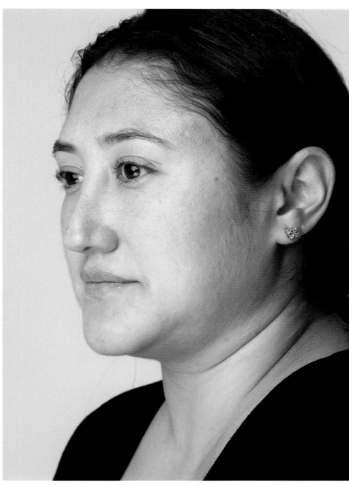

My parents came to America in search of a better life, although I can trace my Ecuadorian roots back seven generations. We arrived when I was a young girl and our family pursued the American dream with hard work and determination. America gave me the opportunity to have free education in the public school and, with the assistance of financial aid, to go to college. This is truly the land of opportunity; you just need to have the drive to pursue what you want.

Anna Salguero/Advertising Executive/Ecuador

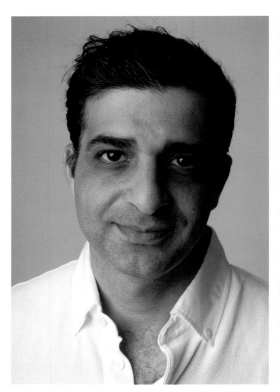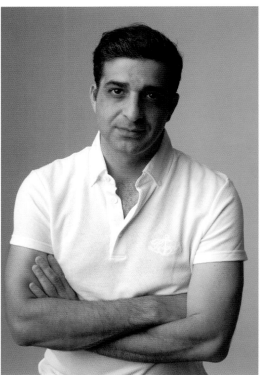

I was born in St. Louis, Missouri, but my family has been in Damascus, Syria, for over one thousand years. We can actually trace our family roots back that far. I have had the opportunity to live in Damascus, but my wife and children and I live on the East Coast, where I have my own private medical practice.

Sam Farah/Ophthalmologist/Syria

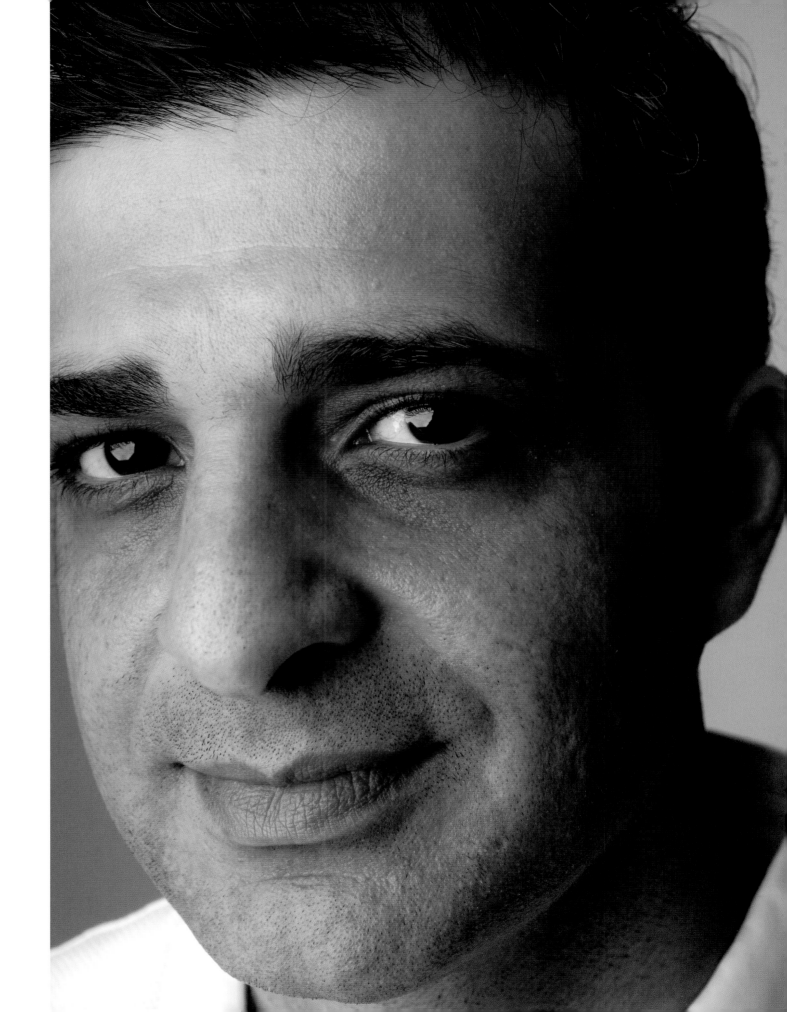

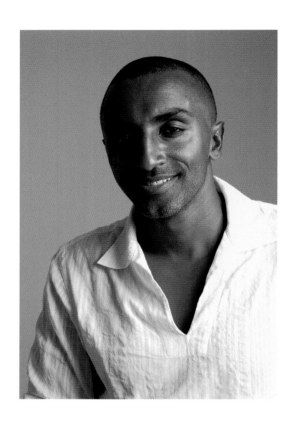

Samuelsson

I am an adopted child, and as one, we always think of two places as "home." It then almost makes sense as being natural to ultimately seek out America as an adult, because this is a place where everyone is an immigrant or comes from somewhere else—and has a special story to share. I don't know any other country where it's completely natural and okay for me to long for Swedish meatballs, Ethiopian injera bread, and an American burger. When I see these three dishes and tastes, I see my home countries. I'm always grateful for the incredible open-mindedness it took for the American generation before us to accept this new generation of Americans; and that's a responsibility we have to pass on to the next generation, because of the constant addition of ethnic "layers" that are eternally added to our population.

Marcus Samuelsson/Chef/Ethiopia, Sweden

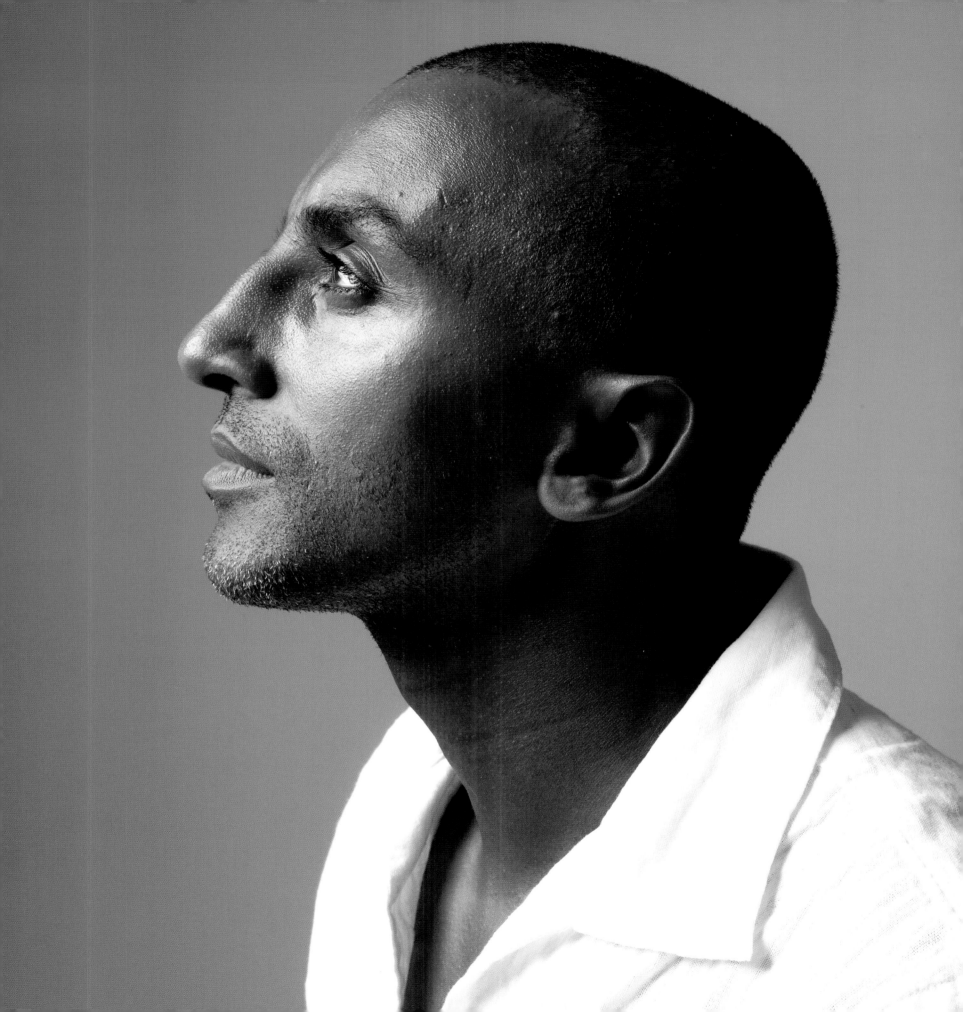

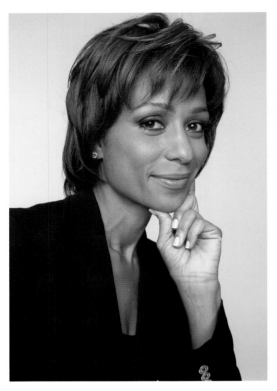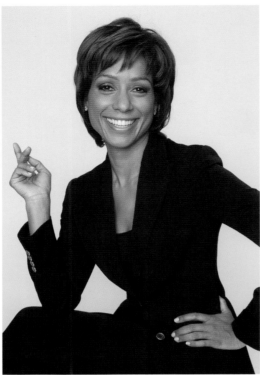

My father was a student from Nigeria who went to Minnesota where he met and married my mother, a German-born student. I was born in Washington, D.C. My passion for news started at an early age. After graduating college and back-packing through Europe, I quickly embarked into the world of television—first as a desk assistant with David Brinkley at ABC News, then as a reporter and now as an on air anchor in New York. My passion for news is equally met by my drive for giving back to the community. With a little time and effort we can all make a difference.

Sade Baderinwa/News Anchor/Germany, Nigeria

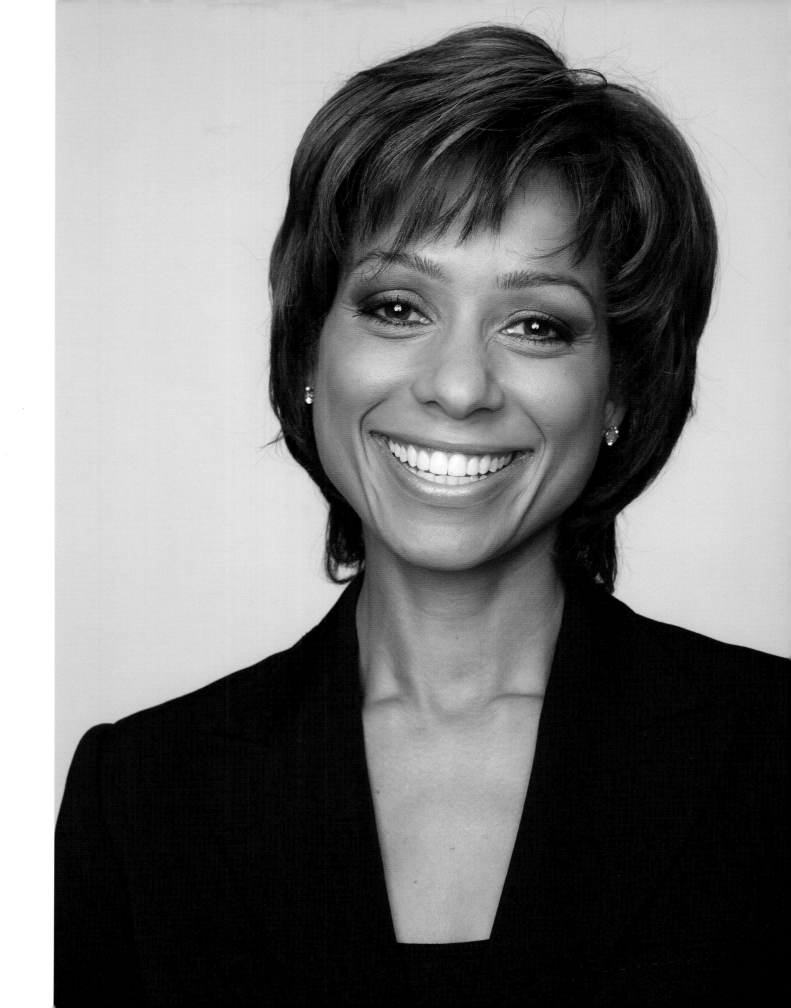

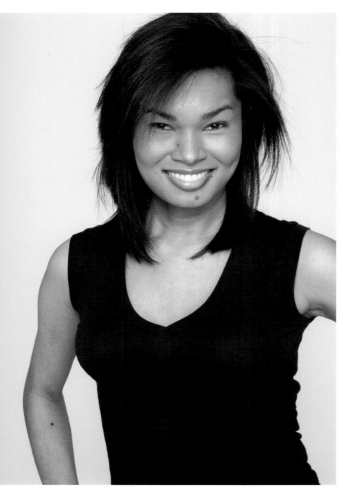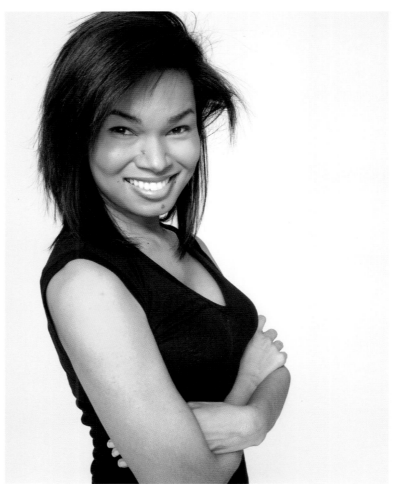

Cabinatan

My maternal great-grandparents moved from the Philippines to Hawaii and my father's family is originally from Panama. My parents met in Hawaii, while my father was in the military and decided to settle there, where they had two children. My dreams took me to the mainland however, and at twenty-one I decided to discover the rest of America by moving there.

Vanessa Cabinatan/Hospitality Manager/Panama, Philippines, Spain

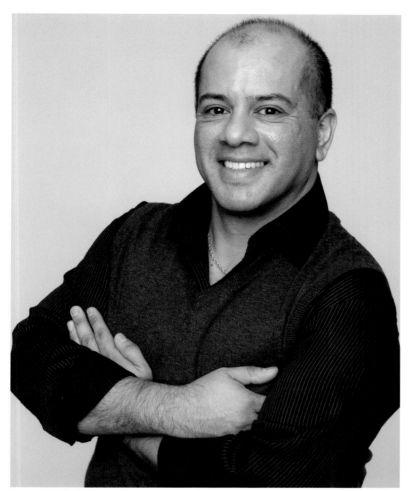 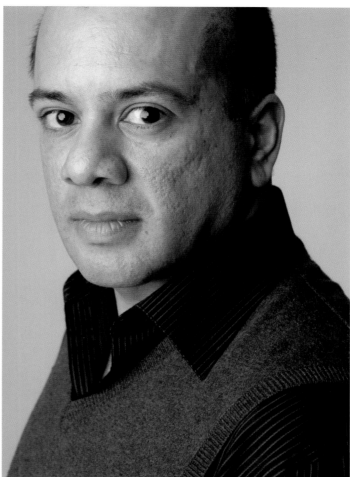

I am the youngest of four children from a town in Paraguay, who came to Cincinnati to study architecture. While I never pursued that career, my travels took me to other parts of America, and I ultimately settled on the East Coast. My son is an American, but I keep him connected to his Paraguayan roots by taking him there to visit family and friends.

Michael Cantero/Private Chef/Paraguay

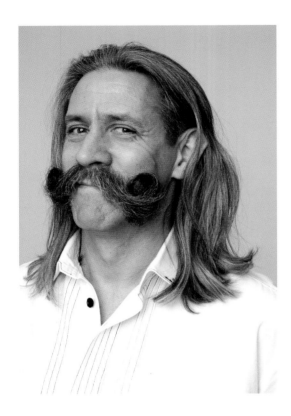

Teszar

My father is from the Buda section of Budapest, Hungary, and my mother is also from Hungary, the town of Kec-skemét. They immigrated first to Canada and then to the United States. I grew up in a Hungarian community and spoke that language at home. However, my parents taught my siblings and me our love of America, as well as the heritage of our background. We are lucky to have both in our lives.

Teszar/Model/Hungary

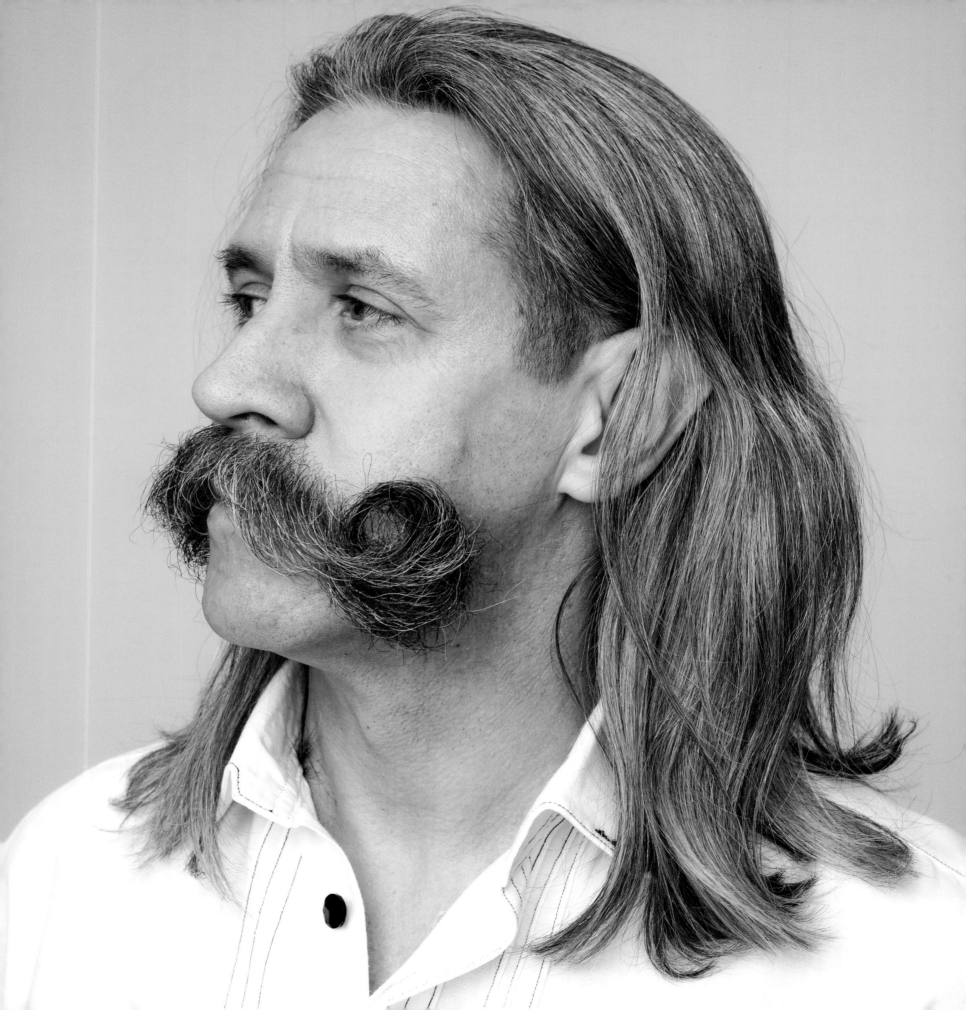

Princeton

I was born in Hollywood, California, one of five children of a Brooklyn-born woman and a father born in Austria; moved to Canada, and then ultimately to Southern California. My work takes me to just about every state in the Union, allowing me to see America in all of its many different dimensions.

Lloyd J. Princeton/Motivational Speaker/Austria, Croatia, Germany, Switzerland

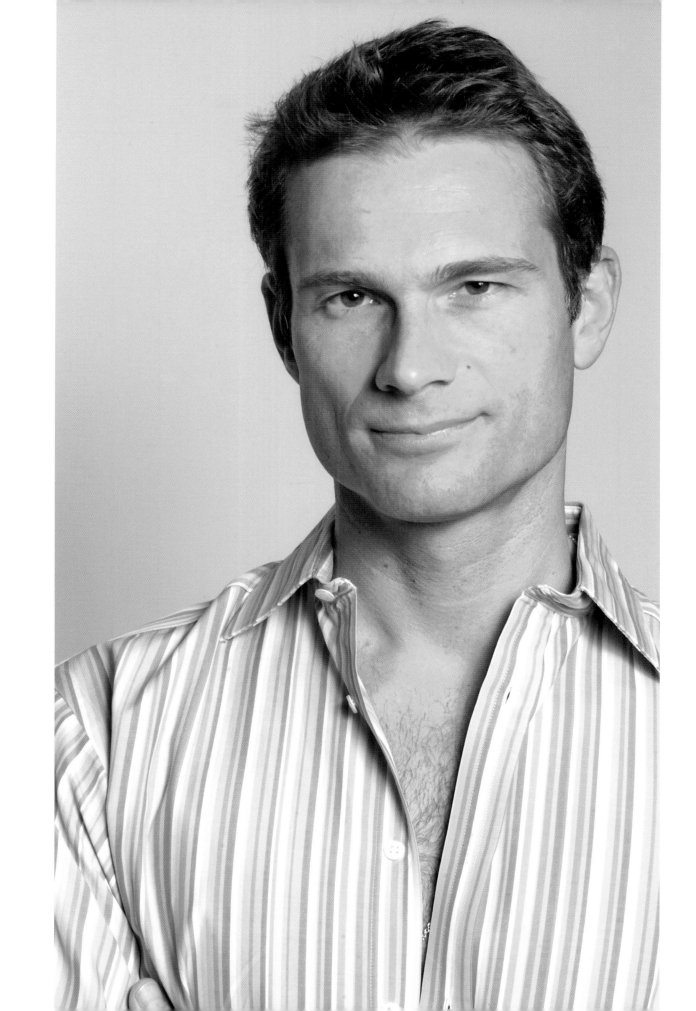

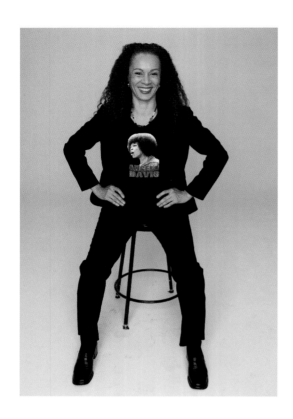

Alexis

My family history includes bloodlines from many different parts of the melting pot of the Caribbean. It was my mother who first inspired me about America. So, I came to the United States in my early twenties—first to Florida to work as a teacher and performance artist—and now as a mother of two American-born children.

Carole C. Alexis/Performance Artist and Teacher/Africa, China, France, Martinique

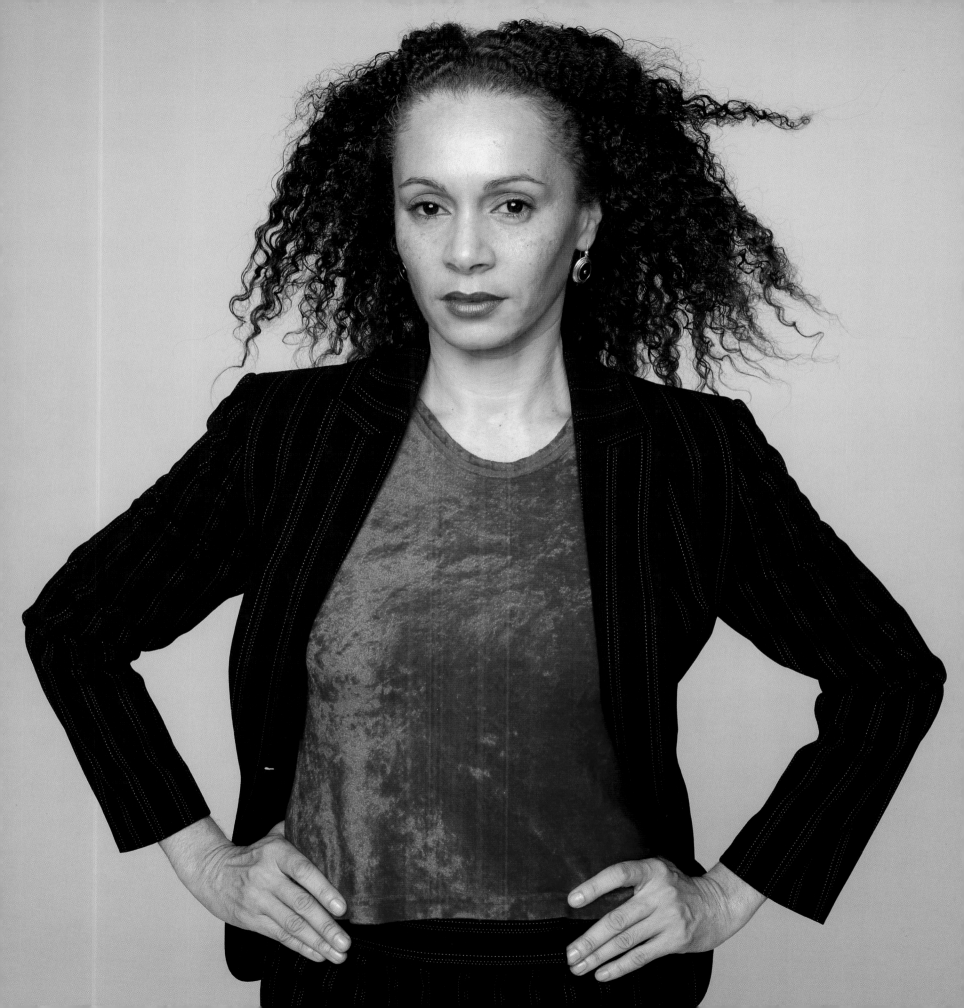

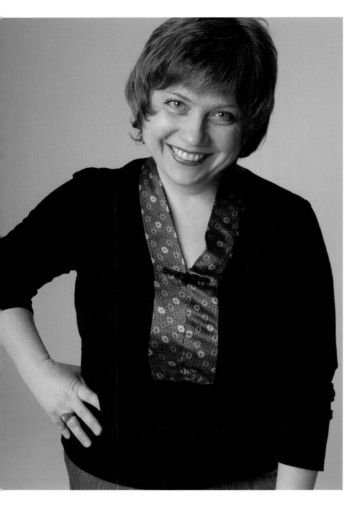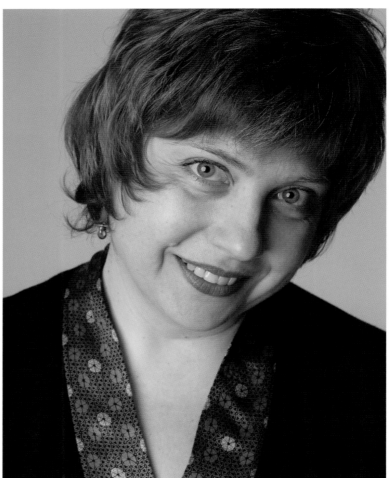

Kazakov

I didn't necessarily expect to leave Bulgaria, but I followed my heart when I fell in love with an American, and came to this country. I am proud to be an American citizen, but take my young son, who speaks Bulgarian, to visit the place of my birth each year.

Milena Georgieva Kazakov/Social Worker, Psychotherapist/Bulgaria

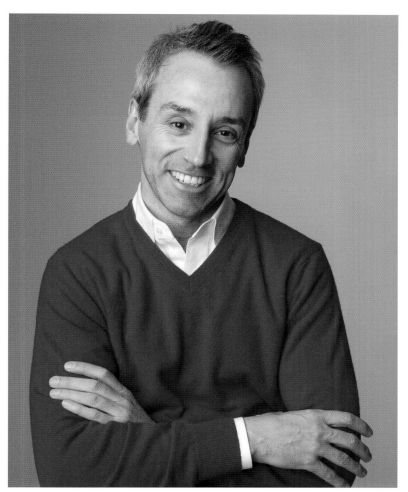
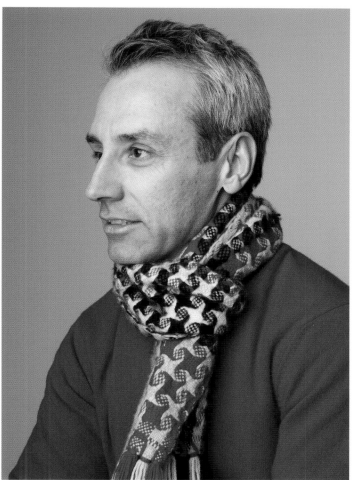

Steinberg

My father escaped Nazi Germany by moving to South Africa, where I was born. But in a pre-Mandela world, I was interested in coming to America to explore how I might have a better life away from the chaos at the time. Today, I am proud to be an African-American, who loves the freedom and possibilities of my country.

Leonard Steinberg/Real Estate Executive/Austria, Germany, South Africa

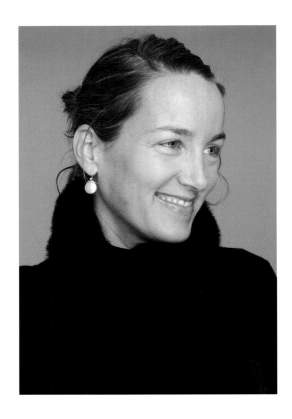

Plagemann

I am a fourth-generation Midwesterner and come from a long line of farmers, ministers, and doctors. While I no longer live in that part of the country, my upbringing, one of understated yet grounded influence, is still very much a part of me. It is what my husband and I hope that I can instill into the lives of our three sons.

Susan D. Plagemann/Publisher/England, France, Germany, Scotland

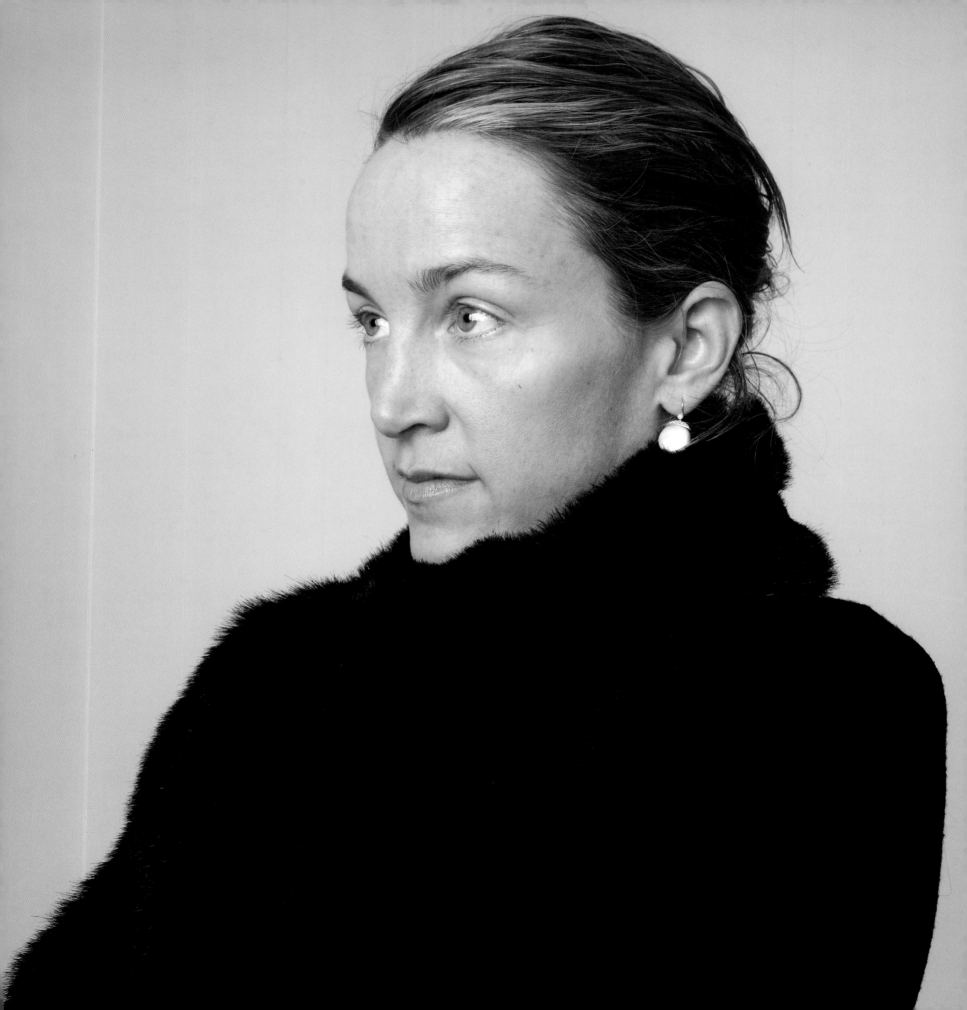

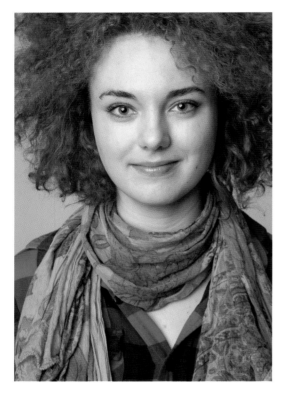 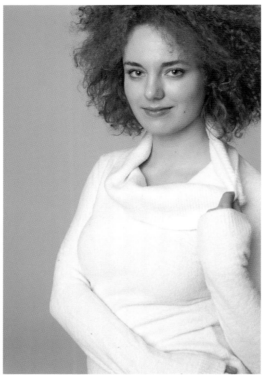

Meese

I'm a fourth generation American from Kentucky, the granddaughter of a farmer. While I am a product of the American heartland, I choose to live in New York City. When I moved to New York for college, I felt like I had found my American home.

Sharla Meese/Performer/Denmark, Germany

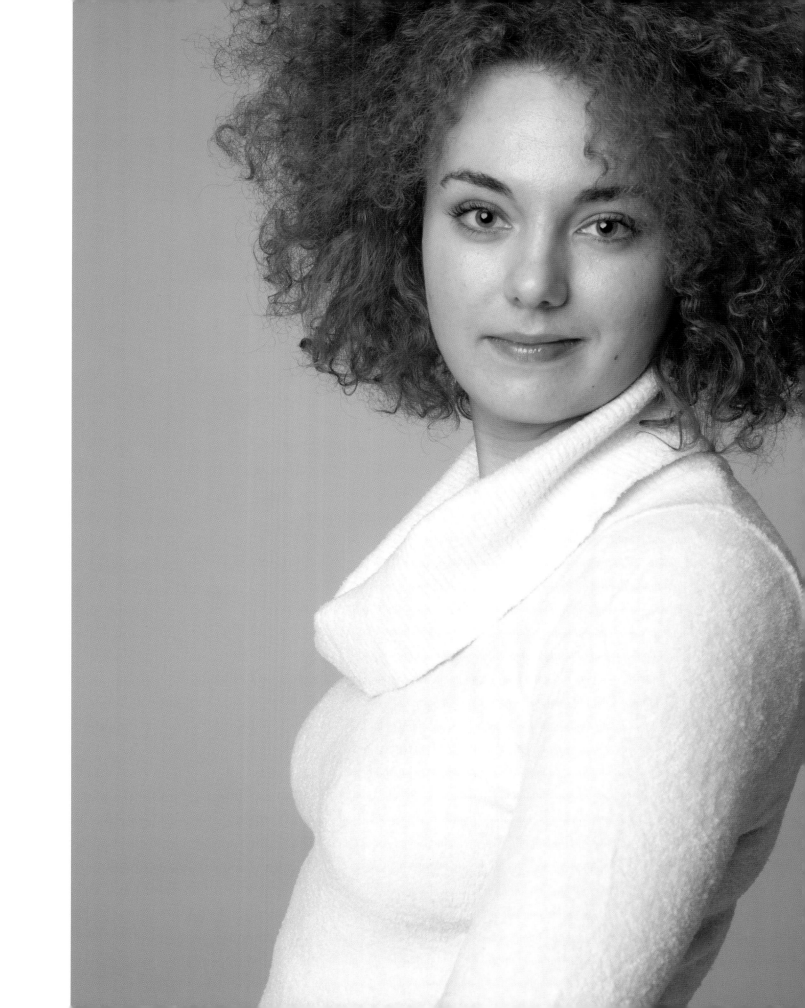

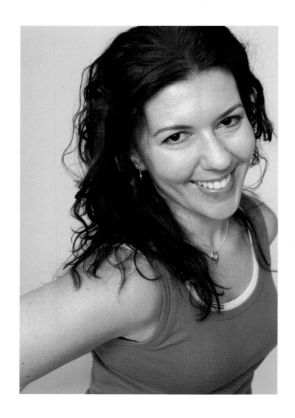

Bortot

My paternal grandparents moved from Portugal and France to Brazil, and my maternal family was from Brazil. Both of my parents were born in Brazil and my father's business brought us to the United States, when I was three months old. Originally the plan was to stay for two to three years, and we have been here ever since. As an American, however, I try to stay in touch with my Brazilian homeland and even teach my daughter the Portugese language, so that she can visit her family there and speak in the native language.

Larissa Bortot/Media Executive/Brazil, Germany, Italy, Portugal

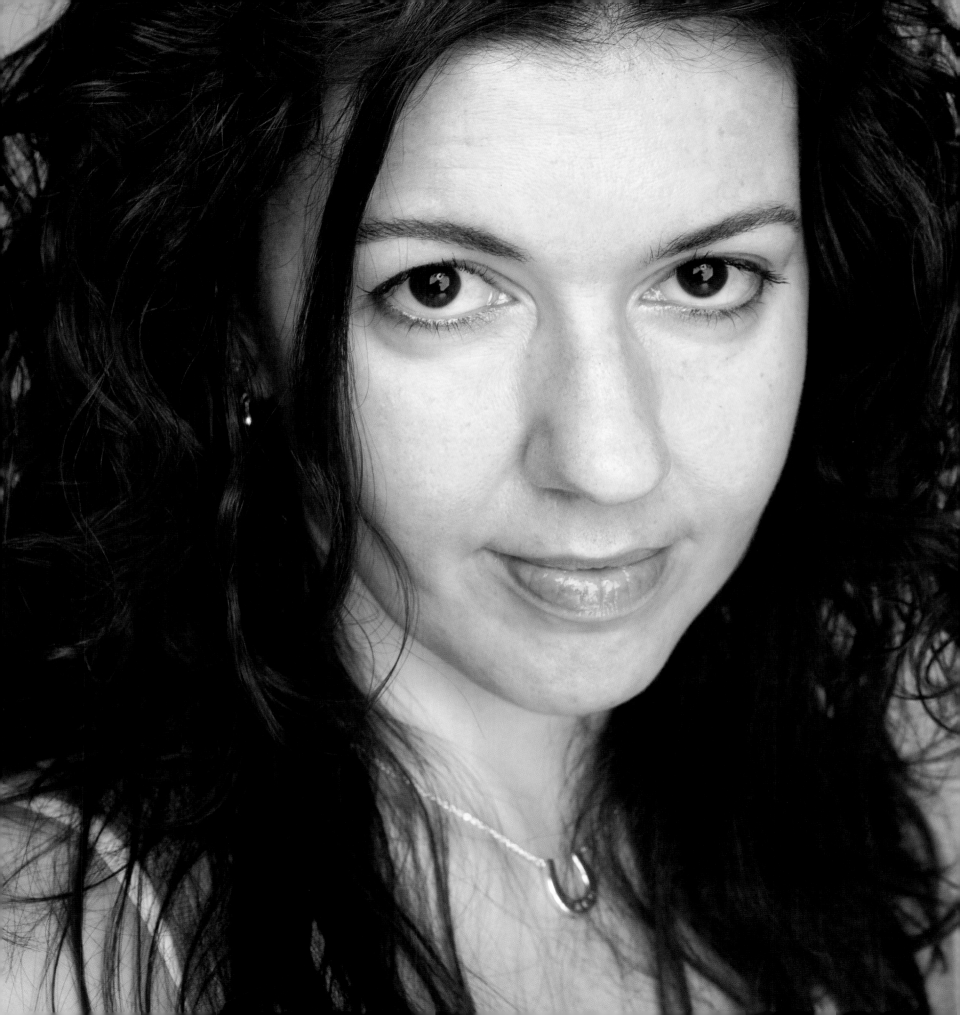

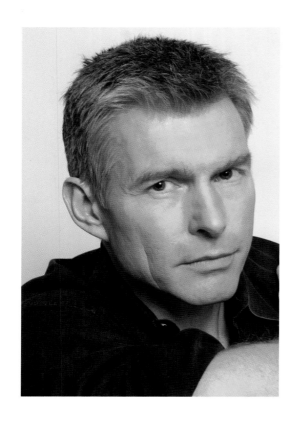

Rogers

I can trace my English and Welsh families back many generations and everyone still lives in the United Kingdom, except me. As a young man, I wanted to discover America and never left. Over ten years ago, I became an American citizen, and I've been told by my family that I'm the first person in my family history to ever have another citizenship. I married an American and live in the United States; we have one daughter.

Simon Rogers/Talent Agency Owner/England, Wales

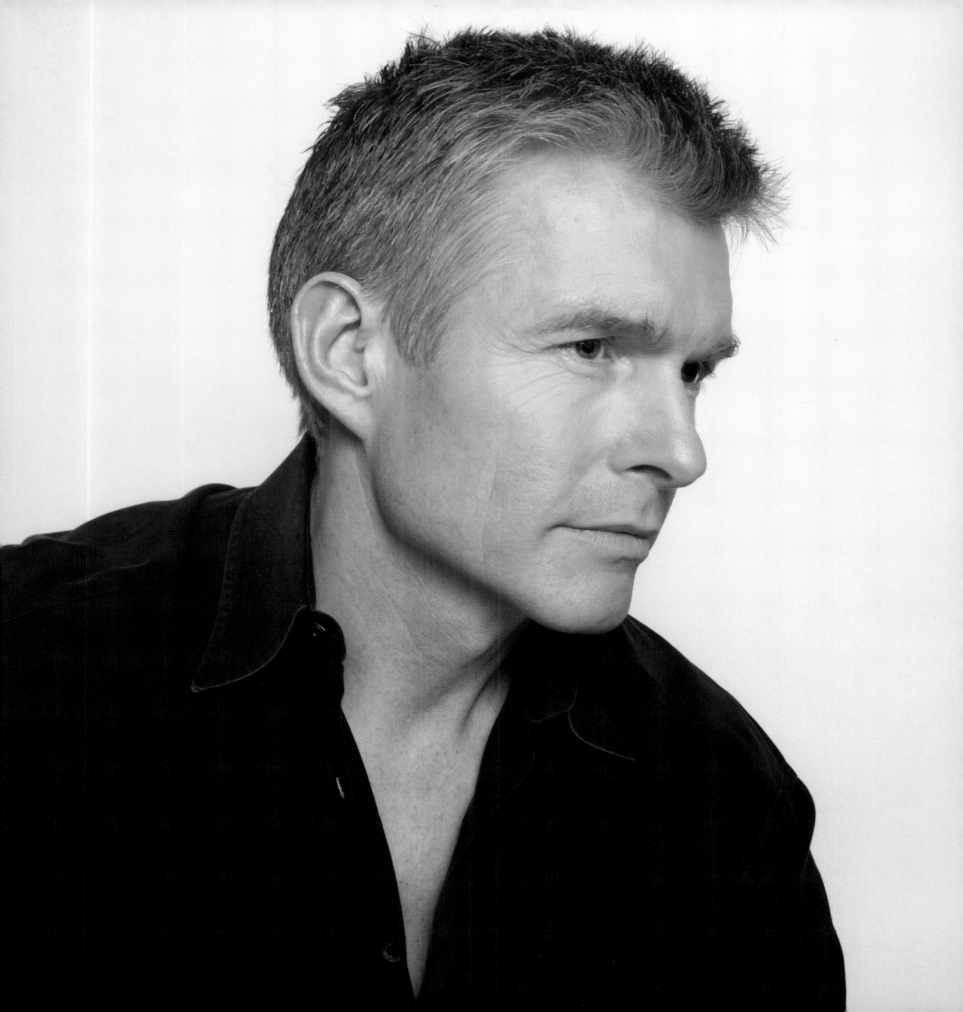

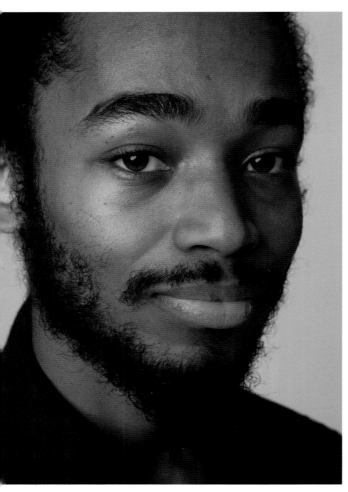 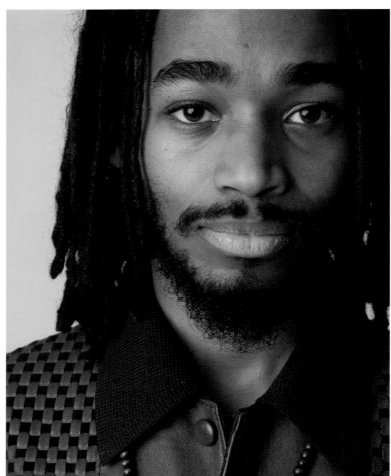

Grauer

I am a fourth-generation American, born in Newark, New Jersey, and come from a long line of teachers, educators, and counselors. My studies were in sociology, anthropology and African studies, and I love teaching, as I continue the family tradition.

Edward "Isaiah" Grauer/Teacher, D.J., Actor/Cherokee, Kenya, Romania

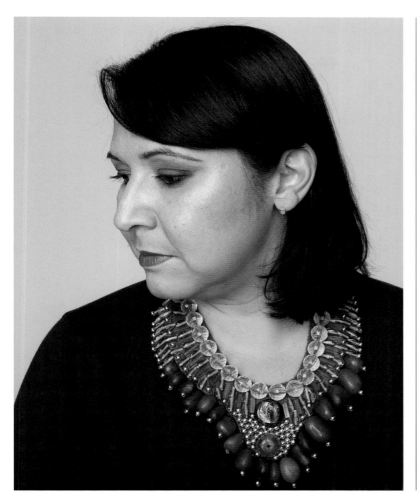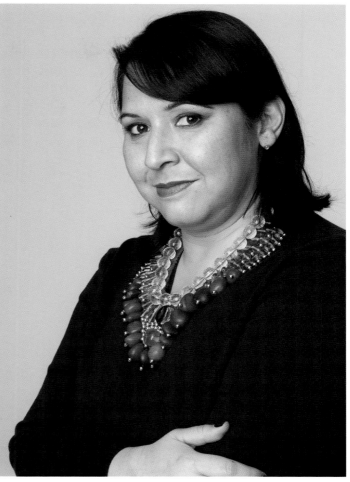

My mother came to America to work at the United Nations and the El Salvadoran consulate and it was here that she met my father, who was in the United States to attend medical school. I have never been to my mother's home country, as most everyone had left, although I have visited the Dominican Republic many times, as most of my father's family is still there. In fact, my husband, who is one-half Osage Indian and one-half Italian, and I decided to get married in the Dominican Republic.

Telma Garcia/Financial Sales Director/Dominican Republic, El Salvador

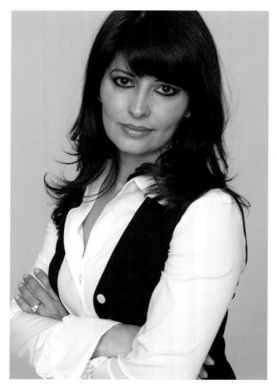 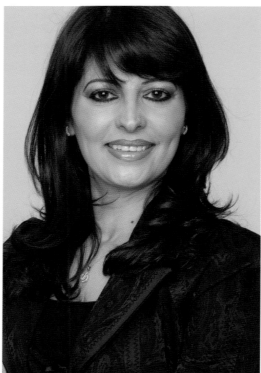

Both of my parents were born in Jordan and they ultimately had ten children, who all lived the American Dream and became college graduates. We have many lawyers, doctors and businessmen in the family and most of my siblings are married to other Americans with Middle Eastern backgrounds, including Lebanese, Syrians, and Iraqis.

Hala Jaloudi/Lawyer/Jordan

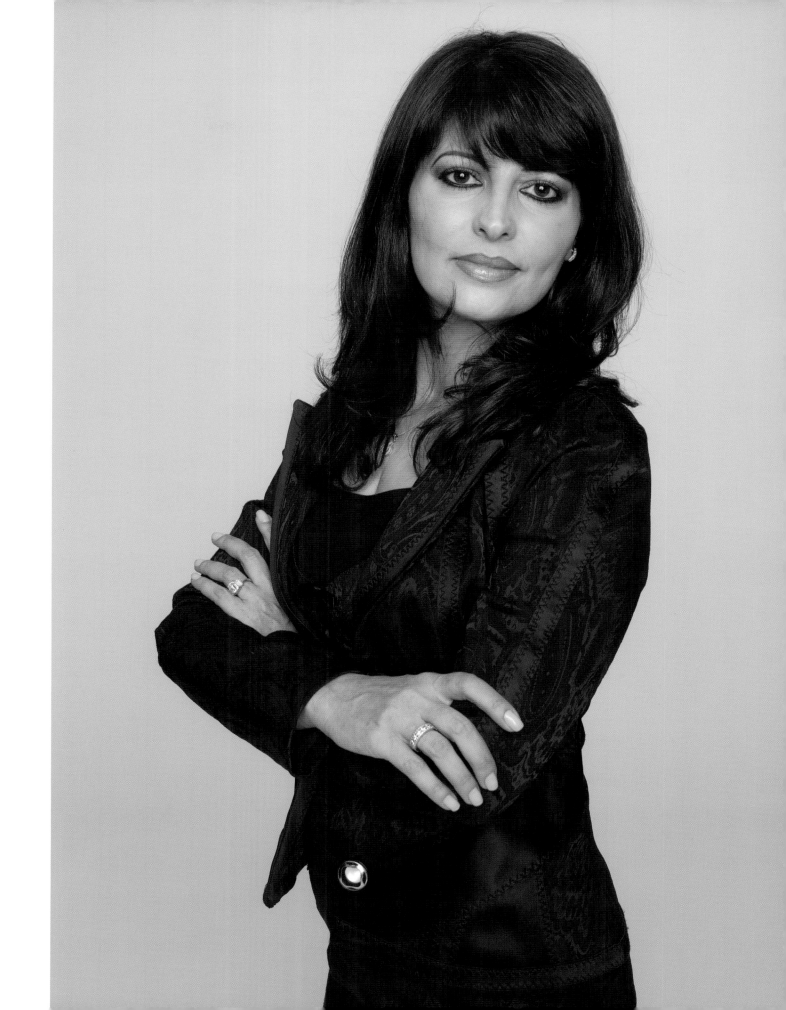

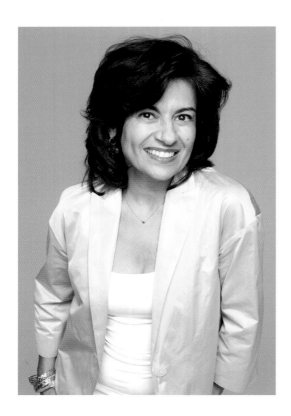

My grandparents came to America to flee Turkish persecution. I was brought up an American first with a strong cultural influence honoring Armenian family ties. We celebrated both American and Armenian holidays, and my Italian husband and our son continue to enjoy my homemade baklava and roll choerag dough, as well as other Armenian traditions.

Donna Kalajian Lagani/Publisher/Armenia

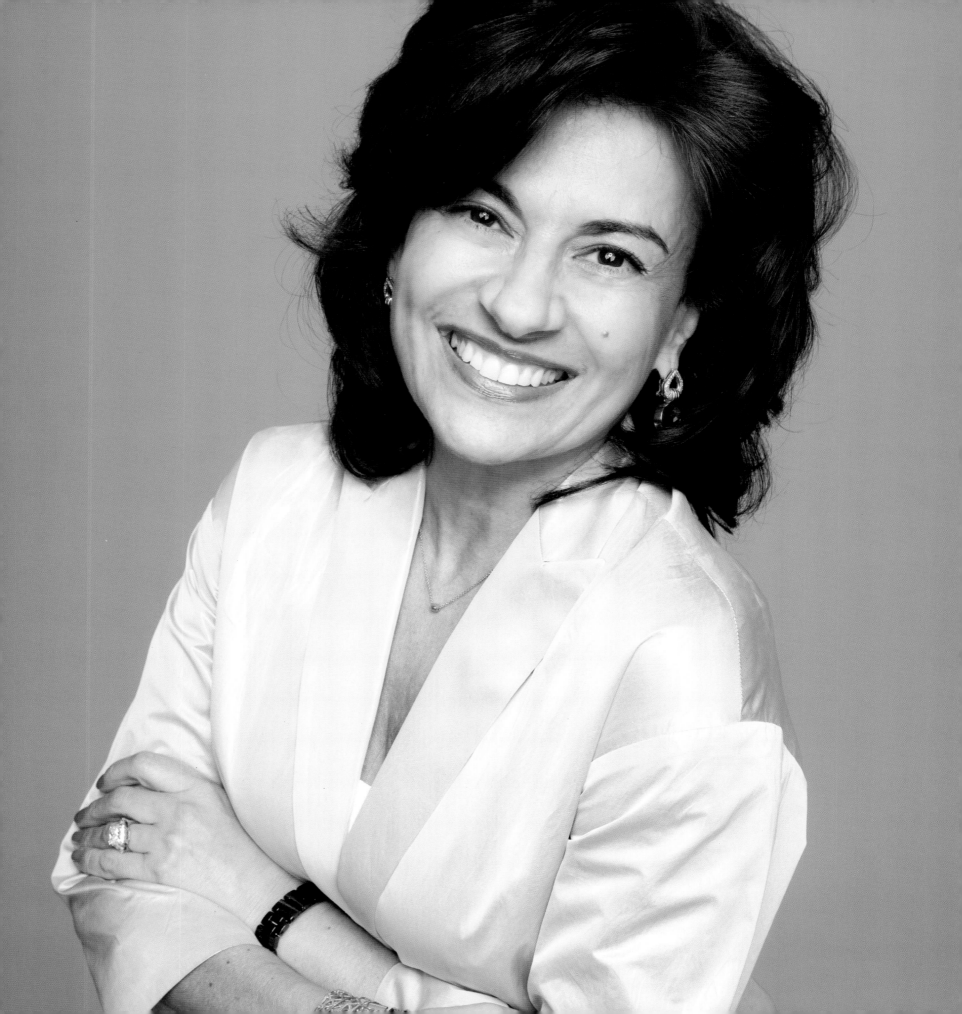

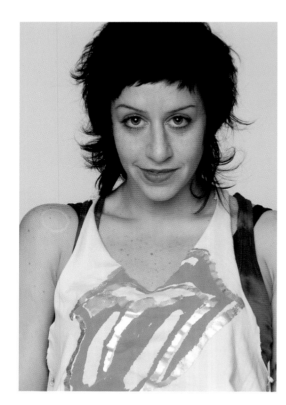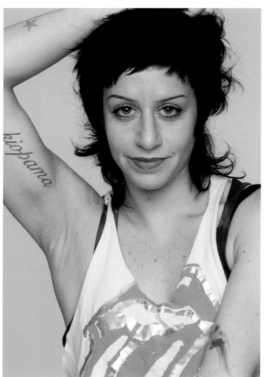

My maternal grandparents fled the war in Europe for Argentina and my paternal grandparents emigrated there from Romania. Both of my parents were born in Argentina, but we came to America when I was six years old. We all became citizens, and I was proud to represent America in gymnastics in the 1992 Olympic Games in Barcelona.

Tamara Levinson/Performer Artist/Argentina, Germany, Romania

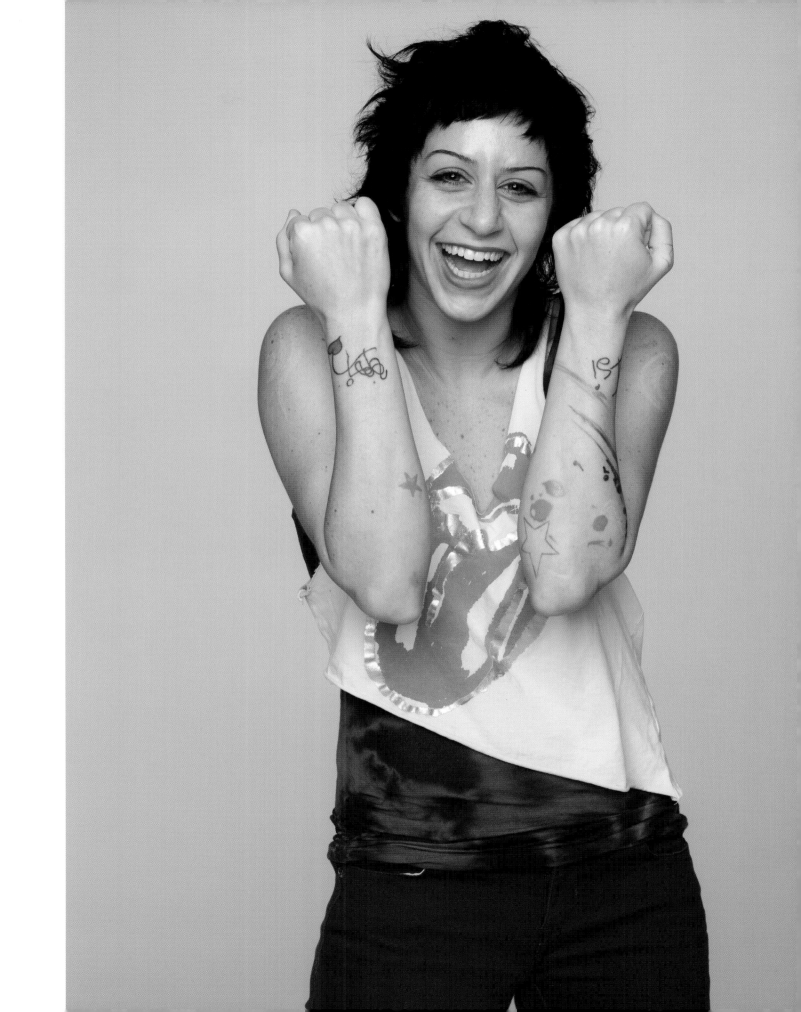

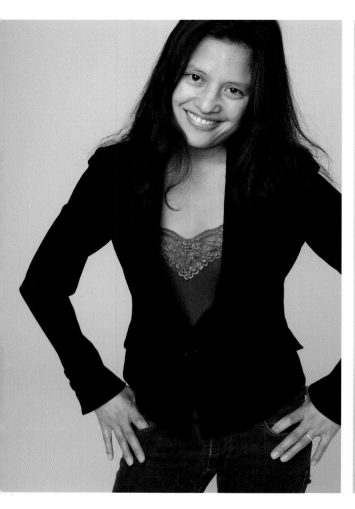
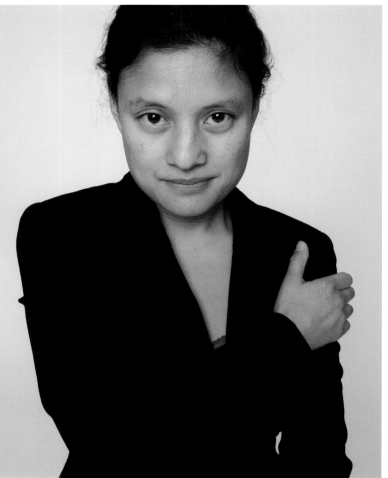

I was born in Los Angeles and spent my early years in Southern California. My multi-ethnic family background prepared me for living in Mexican and Chinese neighborhoods, as well as moving to New York, the biggest melting pot of all ethnic backgrounds. I feel like I fit right in.

Jasmin Estrella/Hospitality Manager/Egypt, England, Philippines, Saudi Arabia, Spain

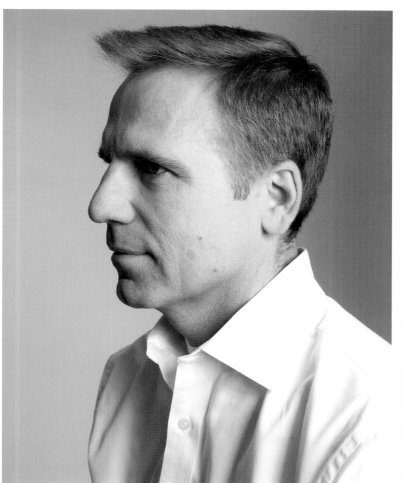
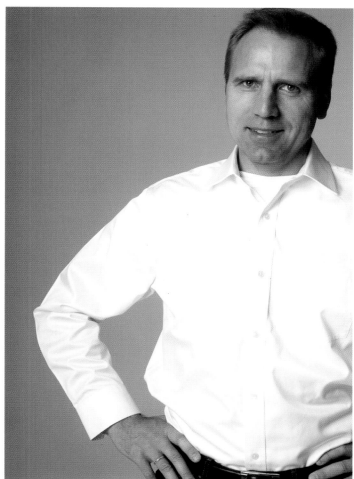

Weiderpass

I'm one-hundred percent Estonian, and we can trace our family roots back to the 1700s. As a first-generation American, my parents kept our home country alive in my mind and while our immediate family is here, we have Estonian relatives who moved to Brazil, Sweden, Australia, Finland, and France.

Mati Weiderpass/Real Estate Developer/Estonia

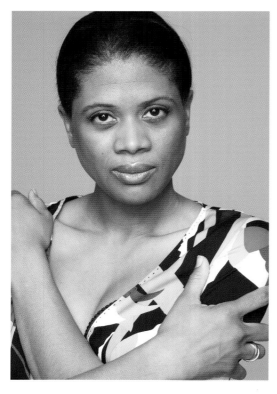 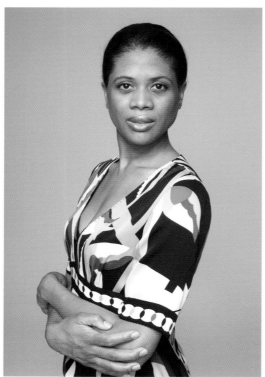

Wilson

I'm a fourth-generation American from Austin, Texas. My great-grandfather was equally black and white, but we also have bloodlines from Cuba and the Louisiana Creole world. As an American, I was always encouraged by my family to pursue my passions and now I'm embracing the idea of environmentally friendly design.

Robin Wilson/Eco-Friendly Designer/Africa, Creole, Cuba, England

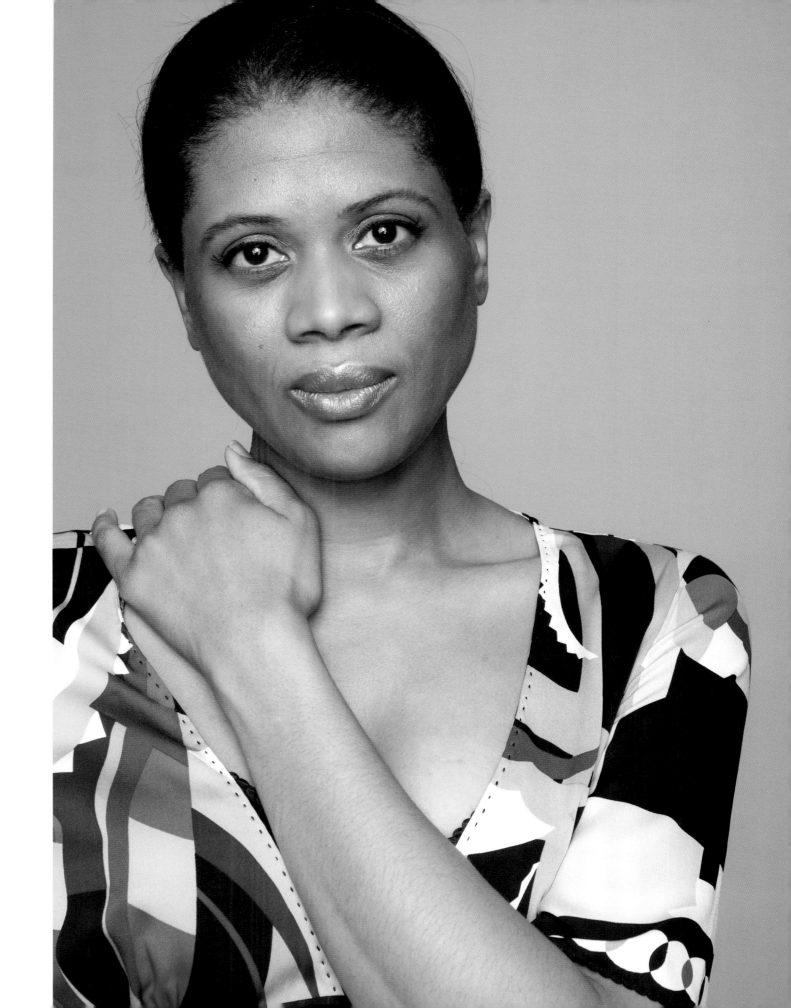

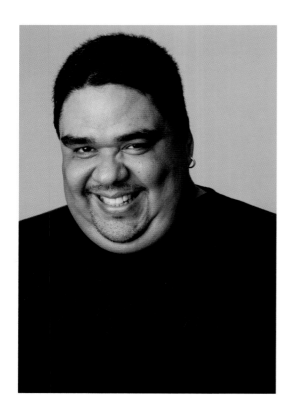

Zalez

I'm a third-generation American, the son of parents who played in big mambo bands together. I have four siblings who live in various parts of America, and I have lived in Japan, London, Paris and Spain, but always come home to my country. My two daughters not only have my bloodlines, but have added Cuban and Italian to continue our family history.

Anthony Zalez/D.J., Producer/Guatemala, Mexico, Navajo, Sioux

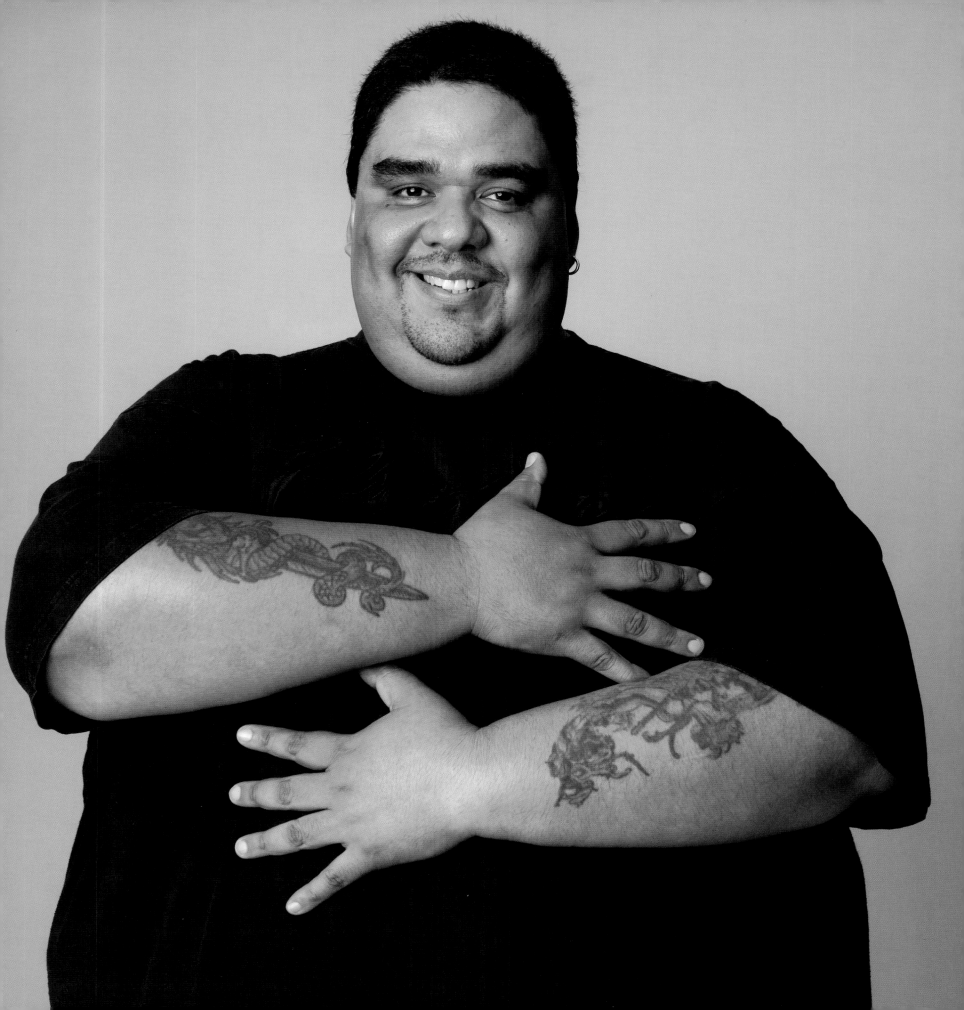

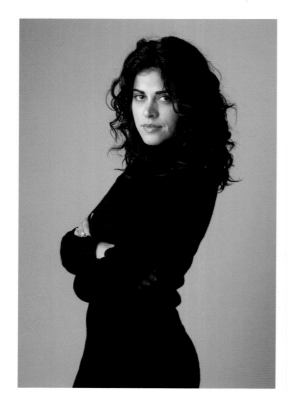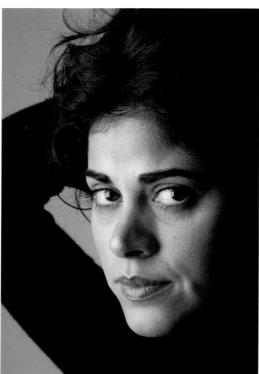

My paternal grandparents fled from Cuba, as they disagreed with the Castro government. They lost everything and moved here to start over again. My father was raised here and went on to graduate school. He taught us that the United States has the best governmental system in the world and also the best opportunities in the world are here if you are willing to work hard for them. Both of my parents are American-born and our family grew up in the American way of life, so we didn't learn a lot about our family history and culture. However, I'm trying to capture some of that now that I am thinking about starting my own family. My husband is an Italian-American, so our children will have multiple bloodlines.

Melissa Tripoli/Special Events Director/Cuba

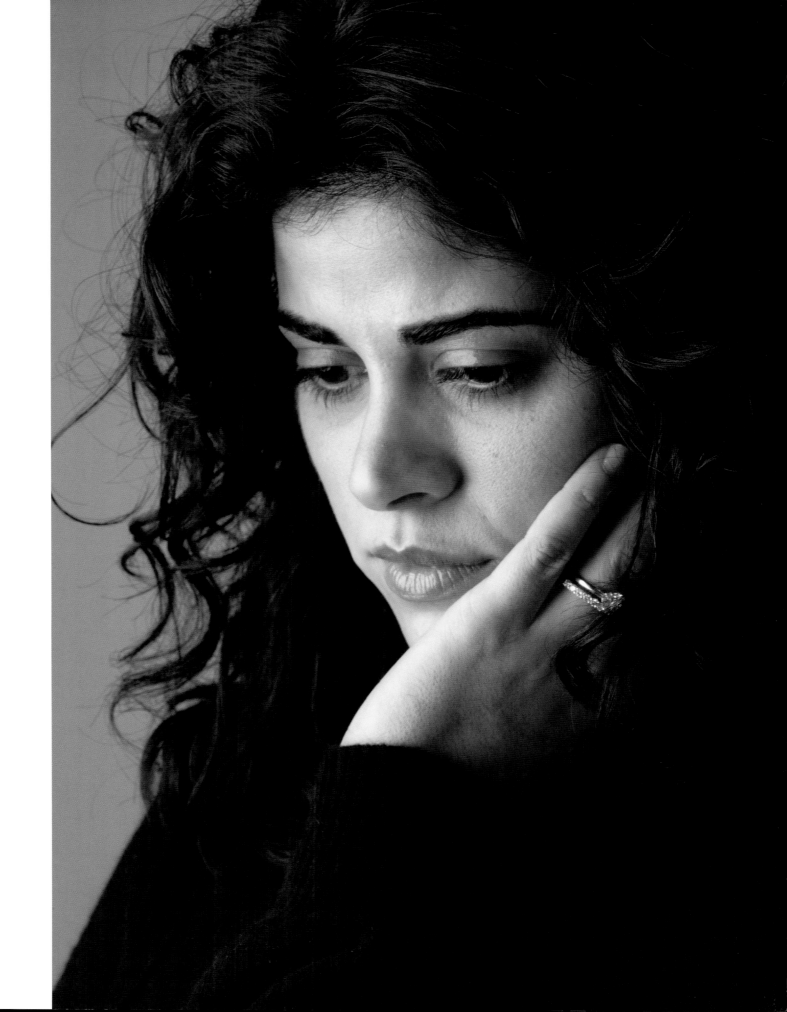

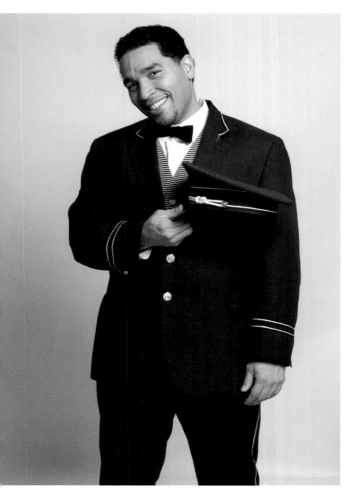
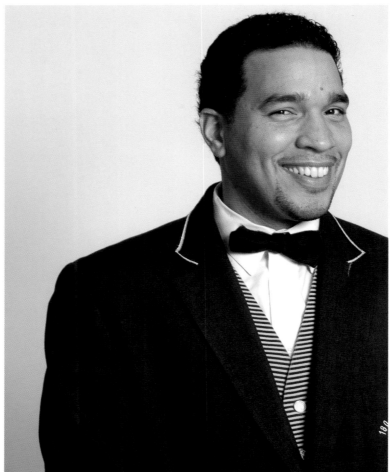

There are seven children in our family; three of them born in Puerto Rico. My father moved from Dominica to Puerto Rico, and he and my mother ultimately immigrated to the United States, where the rest of the children, including me, were born.

Luis Yernet/Elevator Operator/Dominica

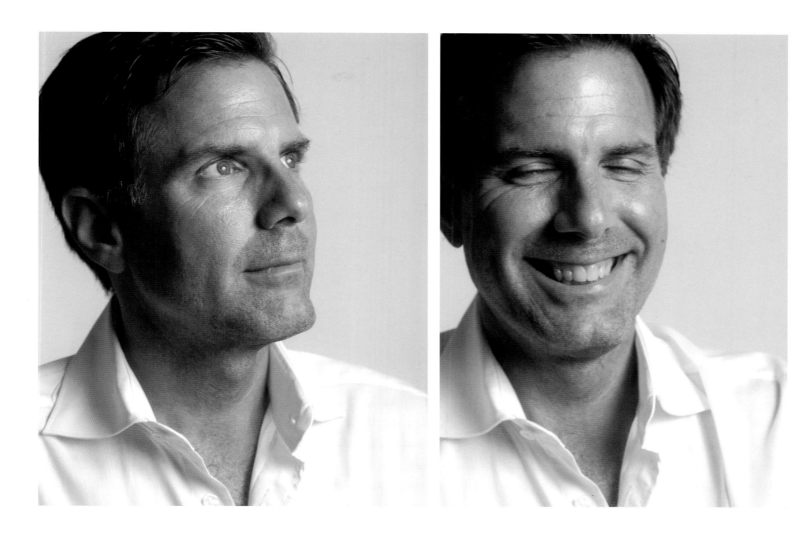

My maternal grandparents moved from Beirut, Lebanon, to Donaldsonville, Louisiana, and I was born in New Orleans. My father is fifth-generation Lebanese/Austrian; but even with that heritage, as a child growing up in New Orleans, I fit right in. Today, most of my friends come from all sorts of family backgrounds. Maybe that is because that was my America growing up.

Richard Ziegelasch/Private Banker/Austria, Lebanon

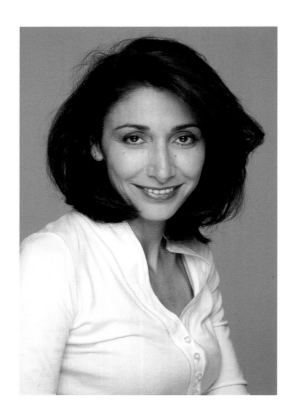

My parents are both physicians who left Iran after the fall of the Shah, resettling in California. I spent my teenage years there, went to university there, and then left for the East Coast for medical school and graduate training. Today, I have a private practice and an academic appointment, specializing in aesthetic plastic surgery. Choosing to make America my home, I have not returned to the country of my ancestors; however the happy sounds and smells of my childhood and the spirit of a rich two-thousand-year history have enriched my life to this day.

Haideh Hirmand/Plastic Surgeon/Iran

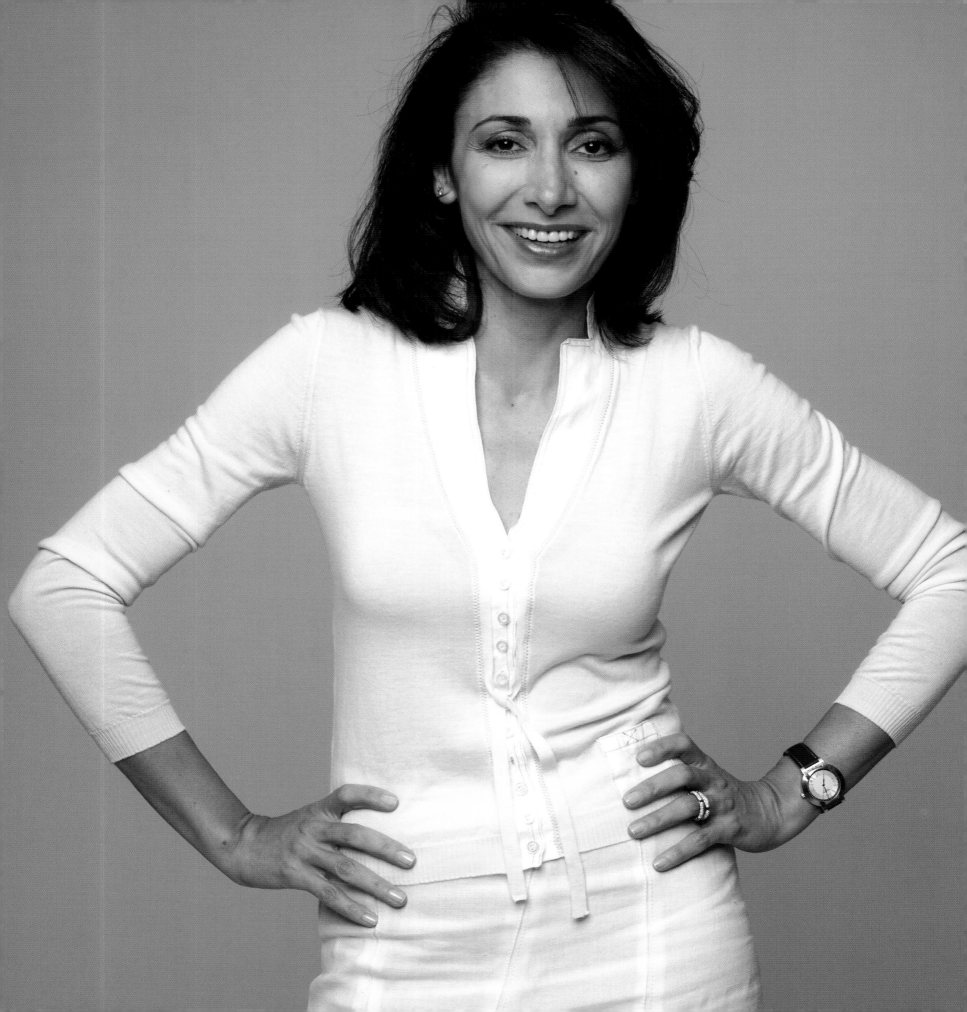

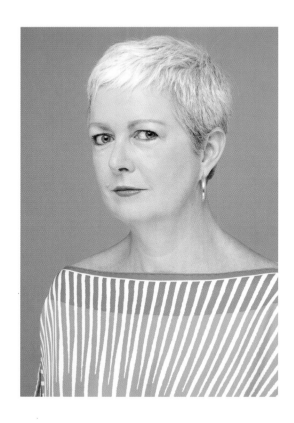

My forefather, English farmer James Booker, came to Virginia in 1657, exactly three hundred years before I was born. The family immigrated farther South with each generation, down through the Carolinas to Virginia, Georgia, and Alabama, my birthplace. Our family fought in the Civil War and my father fought for civil rights in the African-American neighborhoods of southern Alabama. While I keep roots in the South, my Midwestern-born husband and I have lived in the Northeast for all of our adult lives.

Debra Shriver/Communications Executive/England

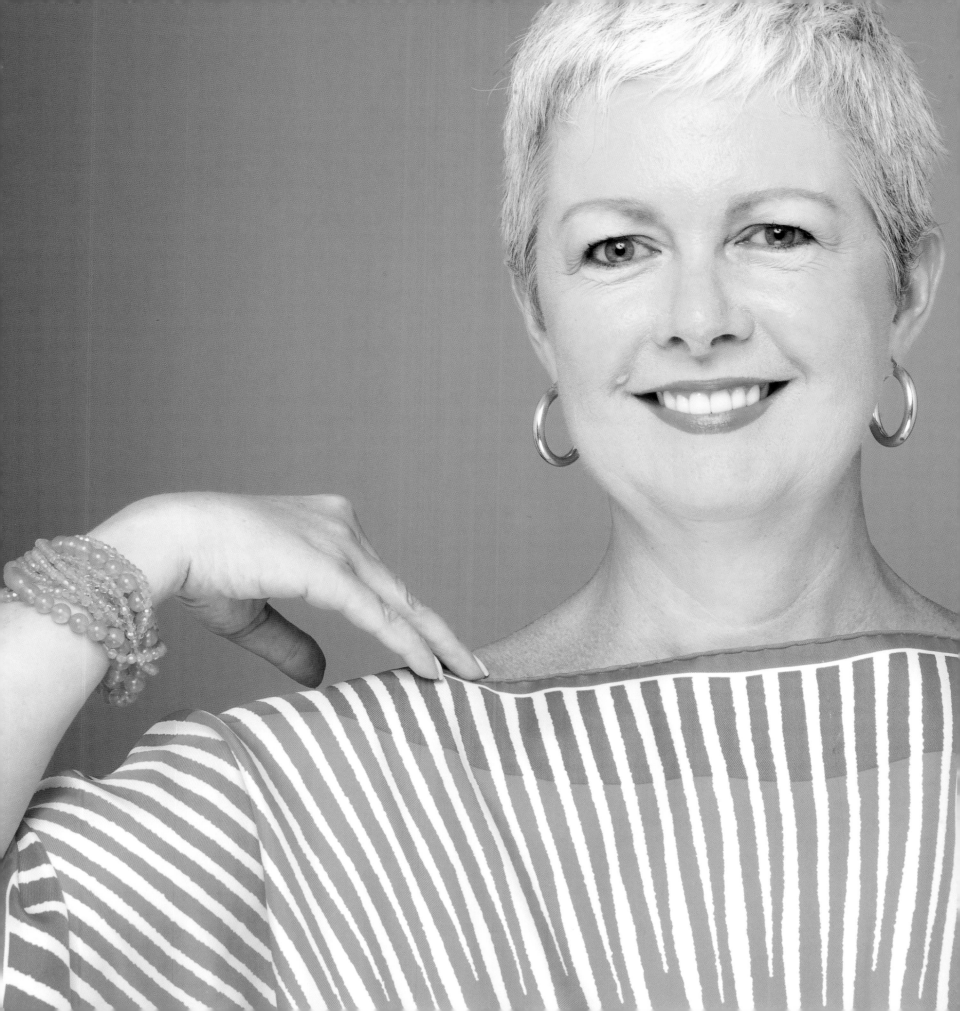

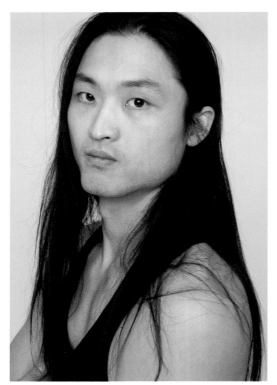 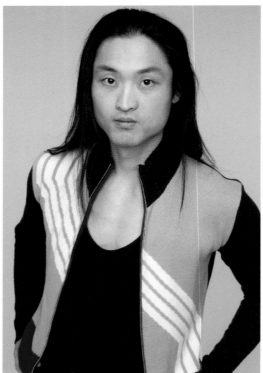

Wang

My maternal grandparents were landowners and farmers in Long Jing, a town in Southern Taiwan, and my father was from Taiwan, too. He developed a life as a chef and this allowed him to travel around the world and to the United States, where he decided to bring my mother, sister, and myself. We arrived in North Carolina in the early 1980s, and both of my parents sacrificed a great deal in leaving, so that my sister and I would have a better life. Much of what I am working for is also for them.

PaiSen Wang/Performer/Taiwan

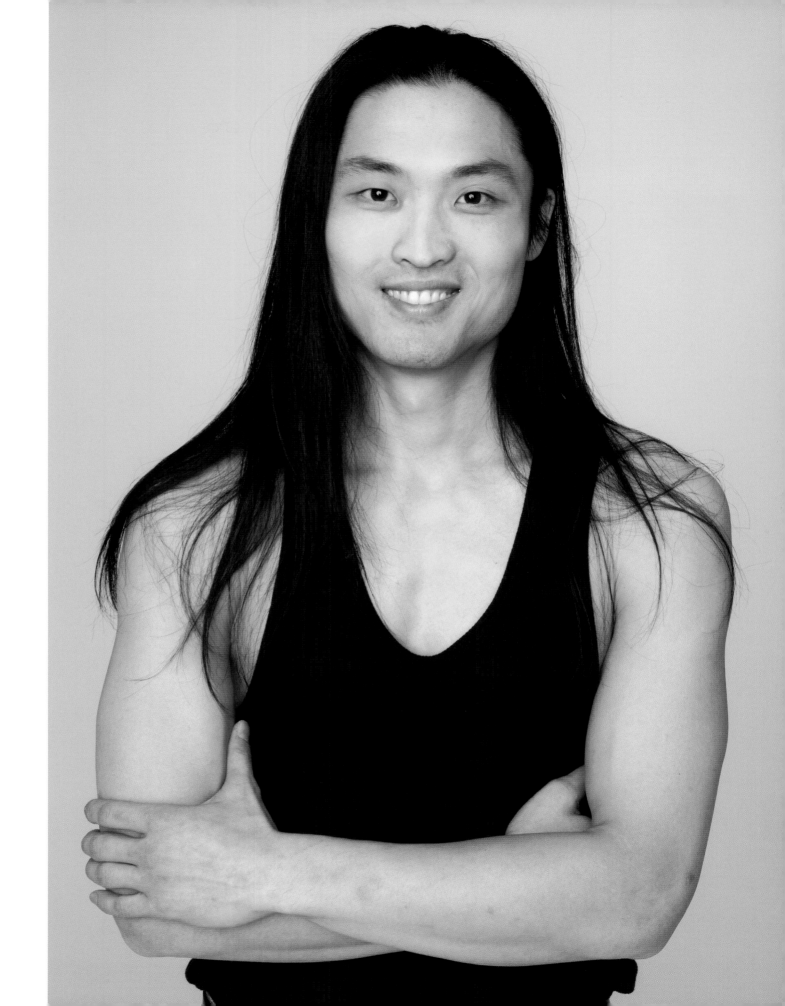

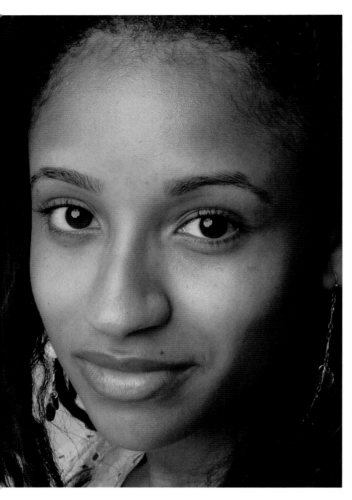
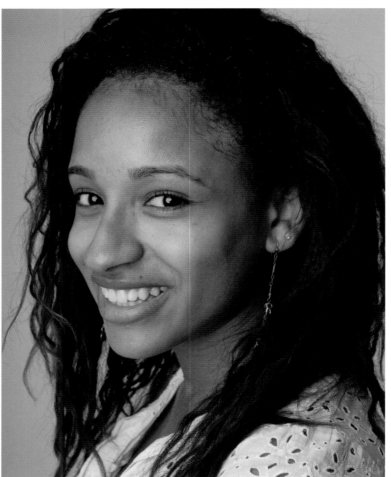

Gumbs

Our family is a mix of Caribbean and British bloodlines. Although I was born in America, I grew up spending summers in the Caribbean country of Anguilla, where my grandfather was born and where we still have an extended family. In learning about our family history, we also learned that my grandmother had Native American blood. So, we have discovered many different nationalities in our family tree.

Ariana Gumbs/Ad Sales Rep/Anguilla, Ireland, Jamaica, Native American, Scotland

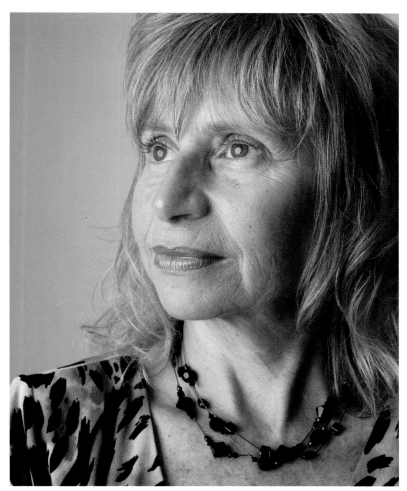 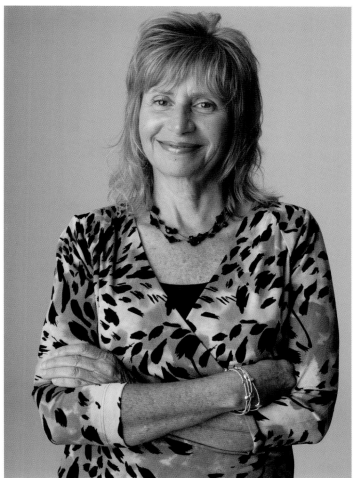

Korn

My parents came to the United States to escape the Algerian Civil War, although the rest of their family emigrated to France. Although we are close with our French family, my three brothers and I have all stayed in America. I believe that I would not have become the successful person I am today had I not grown up in the United States.

Danielle Korn/Advertising Agency Executive/Algeria, Syria

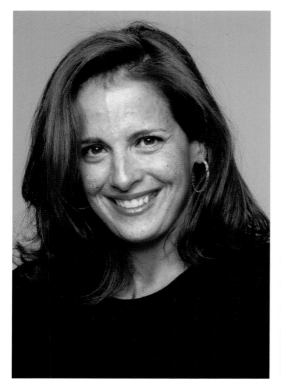 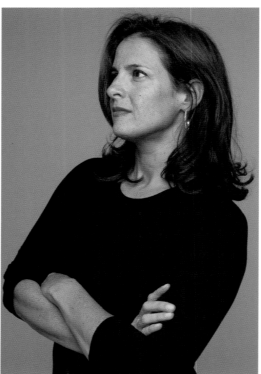

My father was born in Ramallah, Palestine, and came to America to study film, working on the classic movie, *Lawrence of Arabia*, among others. My mother met my father in Ramallah, where she was a refugee. Ultimately, they arrived in Birmingham, Alabama, where my father taught film and where they raised four American-born children.

Freeda Fawal-Farah/Publishing Executive/Palestine

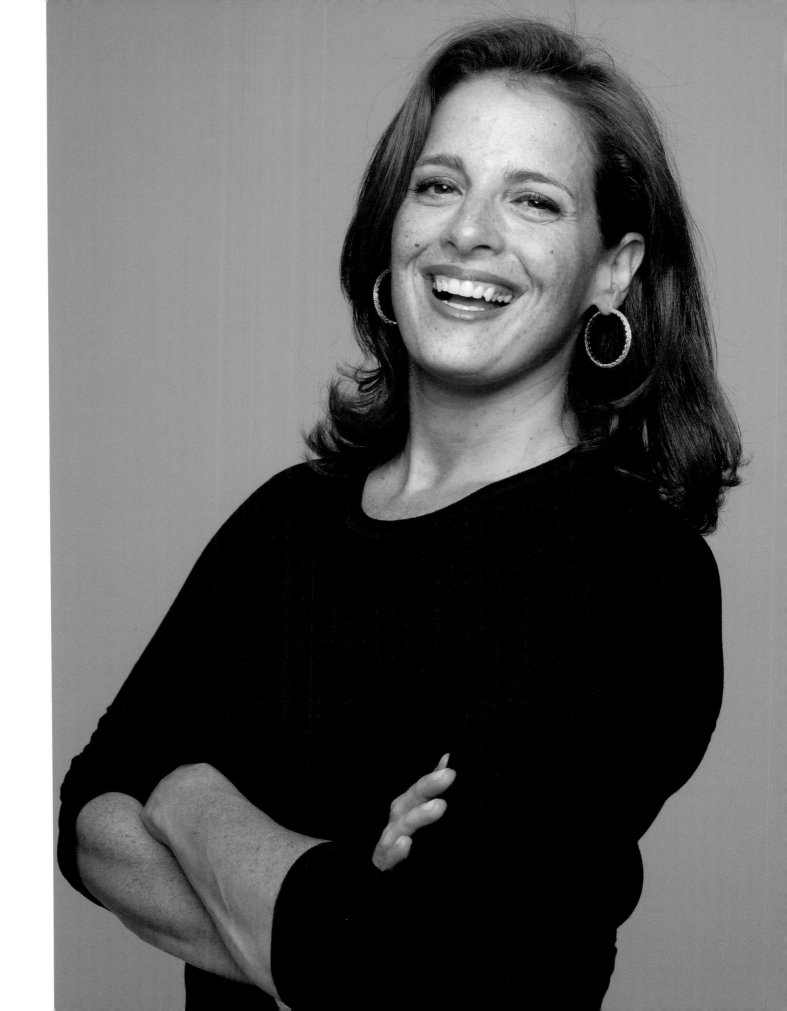

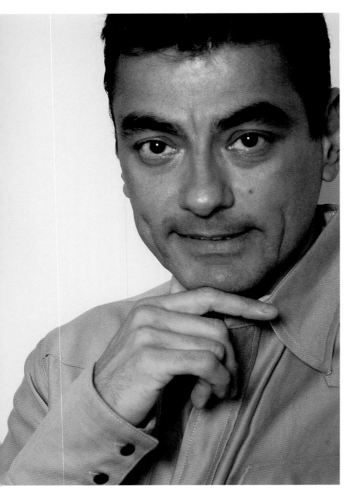 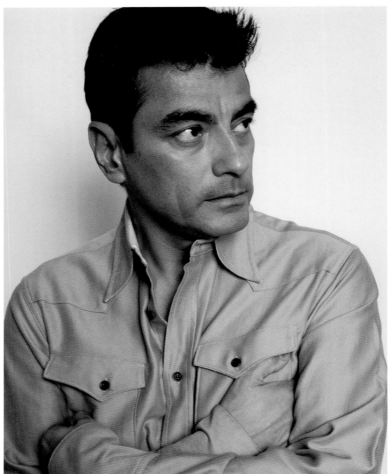

My family moved to Texas from Monterrey, Mexico, in the early 1900s, and I was born in San Antonio. My original passion was music, so I moved to the Northeast on a college scholarship to study clarinet. Along the way, however, I fell in love with medicine and ultimately became a doctor. Currently, I have a private practice in internal medicine.

Robert Chavez/Physician/Mexico

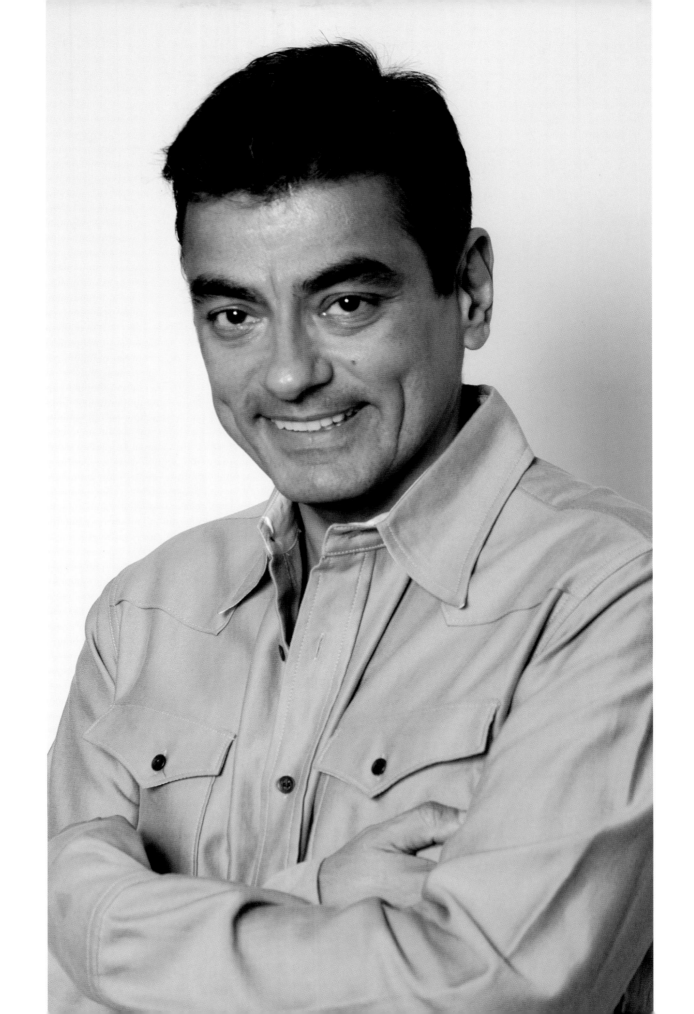

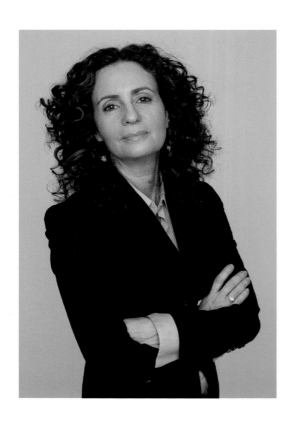

Both sets of my grandparents moved to America in the late 1800s, to escape the religious persecutions that existed in Eastern Europe at the time. Many of them settled on the Lower East side of Manhattan and ultimately moved to different parts of the country, as many immigrants at the time did. Our family took on many professions, from Hollywood producers to positions in finance and the creative arts. My life has been one of wife, mother of twins, and as a creative director for a major publishing company.

Cara Deoul Perl/Creative Director/Austria, Belarus, Poland, Ukraine

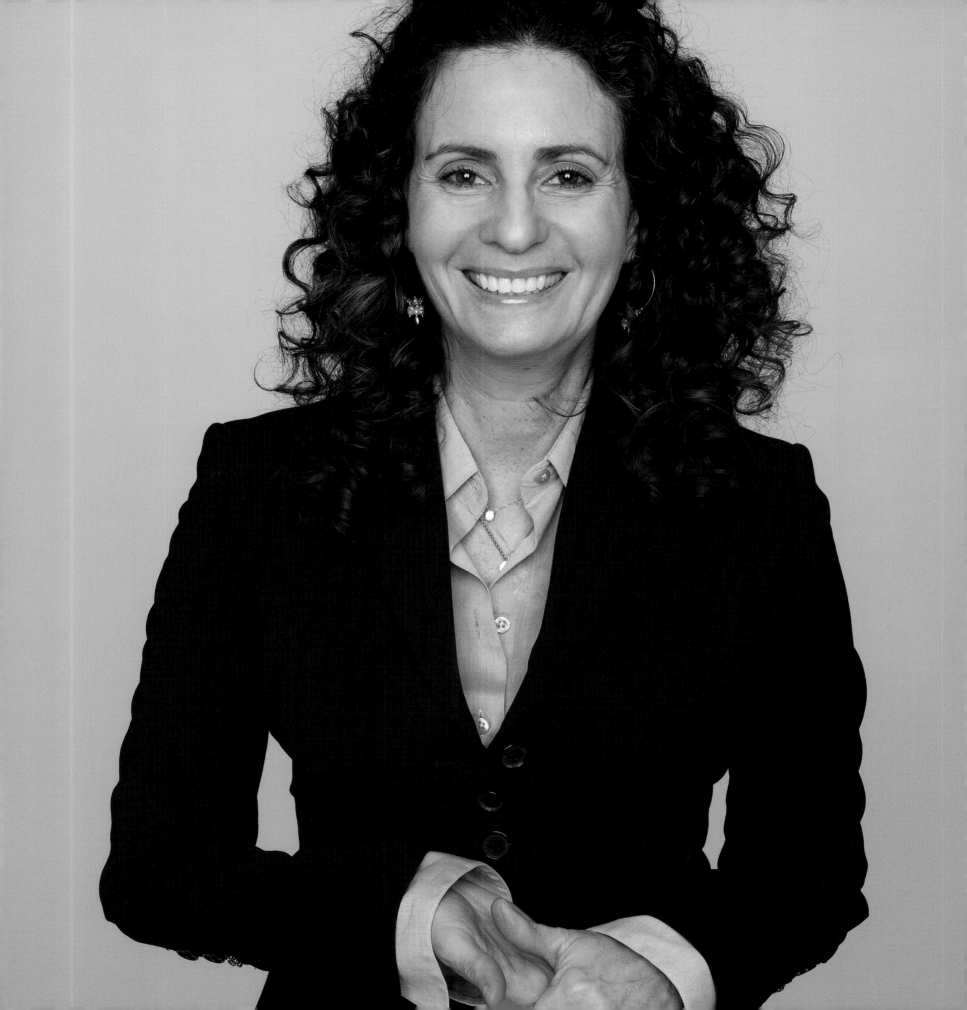

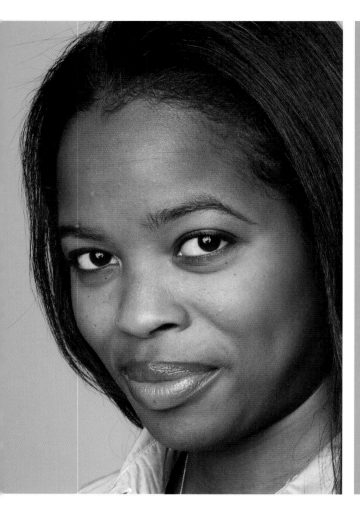 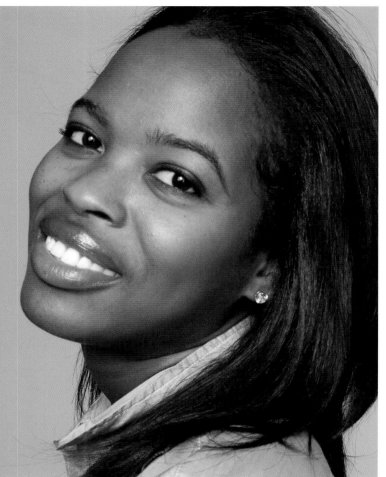

Wilfork

I'm one-hundred-percent Jamaican by background, but we know that we have distant relatives from both Scotland and England, who had offspring through marriages with our Jamaican ancestry. My father first came to America to attend college, and while he returned to his homeland initially, he brought his young family back to the United States, where we have lived ever since. All of our family became naturalized citizens, except for my younger brother, who was born here.

Alicia Wilfork/Advertising Sales Manager/Jamaica

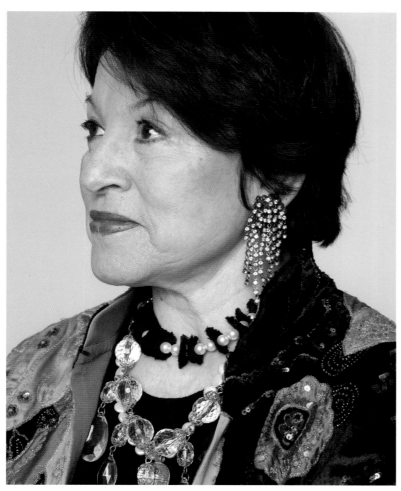 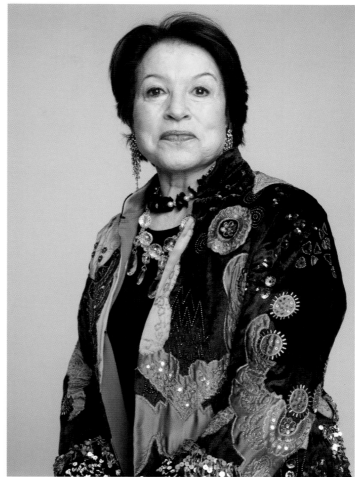

During World War II, my family escaped Lithuania, to Shanghai, China. As a young teenager, I arrived in America, where I entered high school and college. Here, I met an American, fell in love, and had three children.

Dagmar Feldman/Antiques Dealer/Lithuania

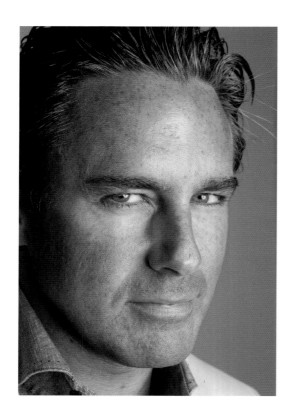

Platt

Both of my parents are descendents of the early Americans, who arrived on the *Mayflower*. The Platt family origi-
nally came from Guilford, Connecticut, but I was born in Boston, Massachusetts. My mother's family had settled
in the Washington, D.C. area. She was a Borden Covel, and a distant relative of the famous Lizzie Borden!

Campion Platt/Architect/England

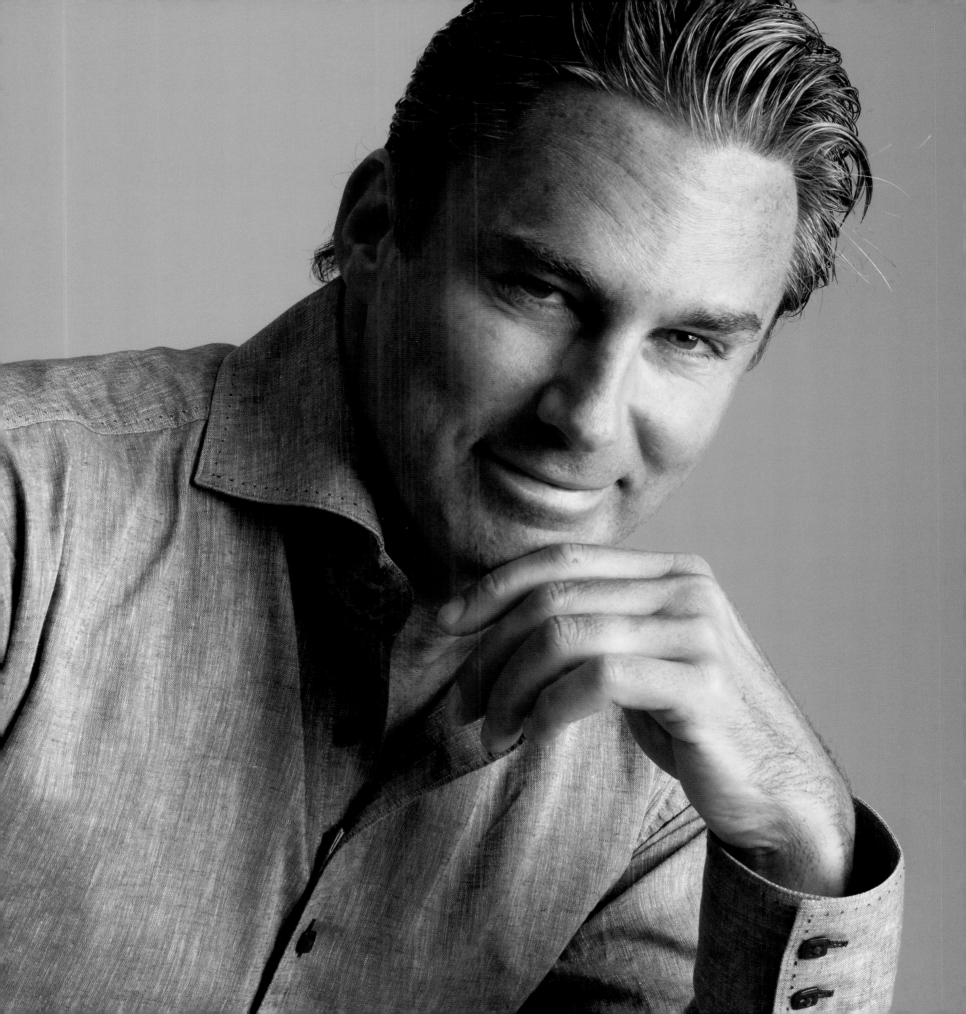

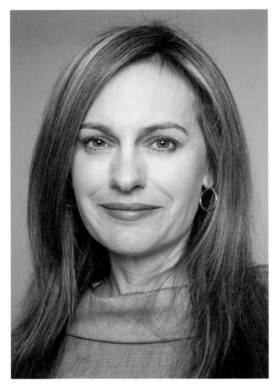 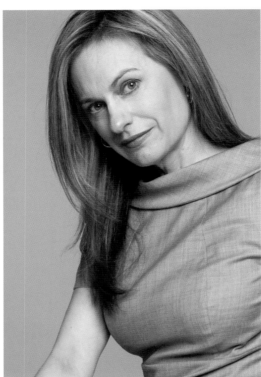

One by one, all four of my grandparents came to Ely, Minnesota, by way of Ellis Island; my father's side from Finland and my mother's side from Slovenia. My father spent most of his life as a miner, but my mother found her success as a singer, in stages across the country. Traditions from both countries were pervasive in my home, from Finnish saunas to making Slovenian *potica* (sweet bread). It provided a sense of pride and belonging, yet it always remained clear that being American came first.

Andrea Luhtanen/Advertising Agency President/Finland, Slovenia

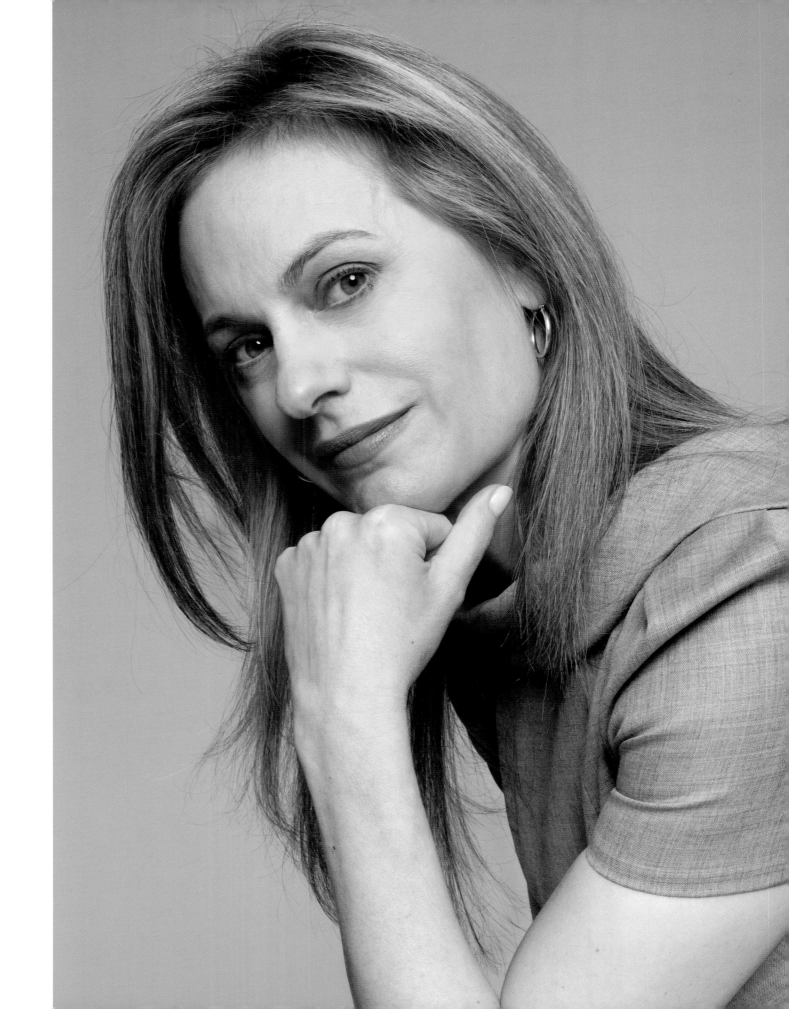

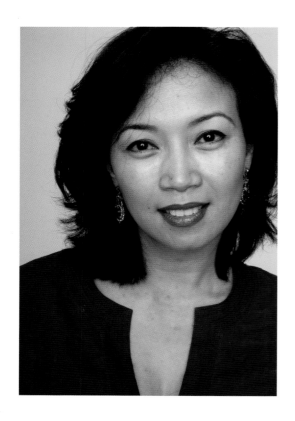

Prak

My father worked for the American Embassy when Pol Pot overtook Phnom Penh in March 1975. Our family—my mother, father, and seven children—evacuated to Thailand and a few months later, we were flown to Camp Pendleton in San Diego to begin our American journey. We found a wonderful family in Evanston, Illinois, that sponsored all of us. We moved there to begin what has been our American life.

Mayanna Prak/Director of Development and Communications/Cambodia, Khmer

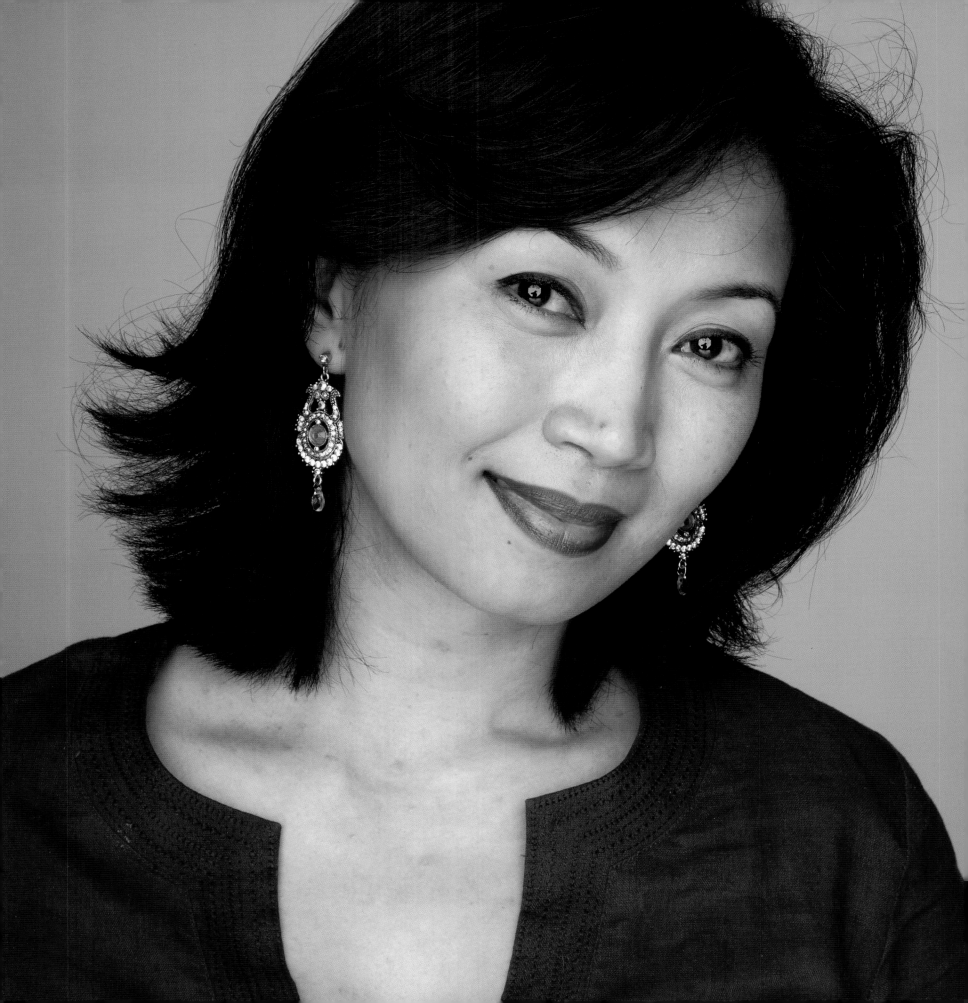

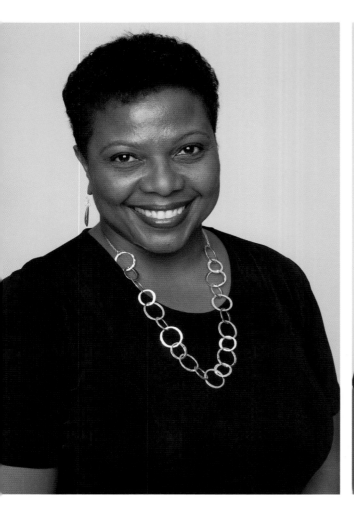
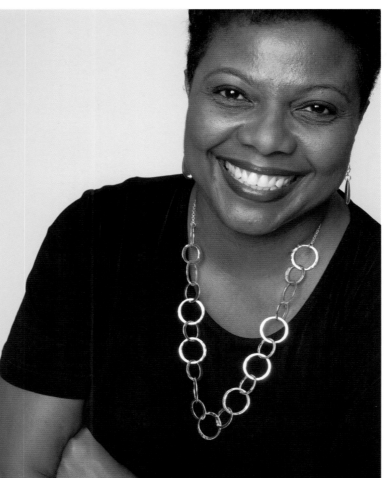

Gumbs

Growing up in Antigua, I always dreamed of coming to America and arrived here for college at the age of sixteen. While I wasn't sure of my long-term plans then, my life took its destiny when I met an American who would become my husband. I became an American and have raised two children here. The United States is now my home.

Carol Gumbs/Corporate Training Specialist/Africa, Antigua, Portugal

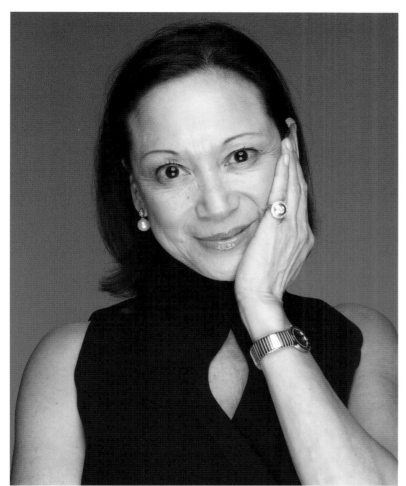 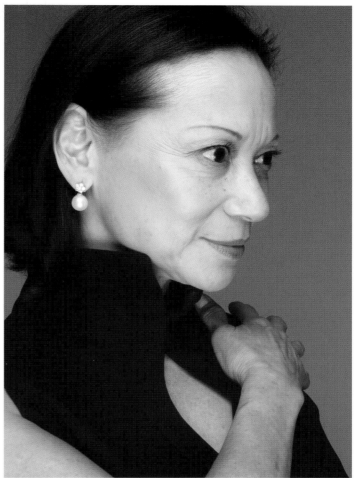

My father was born in Shanghai, China and my mother in San Salvador. My father arrived in Seattle and later joined the United Fruit Company, where he worked for forty years. My mother worked as a missionary teacher in Honduras, where she met my father during a vacation. They moved to America, where they raised three daughters to become citizens of this great country.

Jeannette Chang/International Publishing Director/China, San Salvador

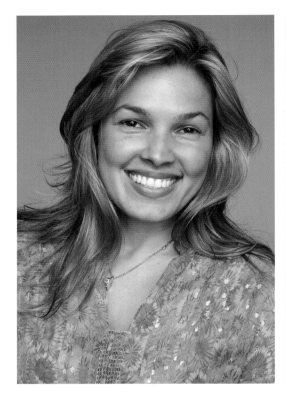 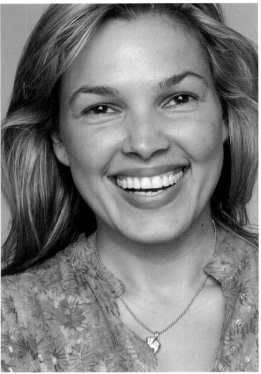

My father's family is Afghan, and emigrated first to Trinidad and then to the United States, after my father had attended college in Ireland, where he met my mother. My parents have three children: one born in England, one in Ireland, and one in Trinidad—and we all came together to America, as a young family.

Renee Dominique/Sales Manager/Afghanistan, Ireland, Trinidad

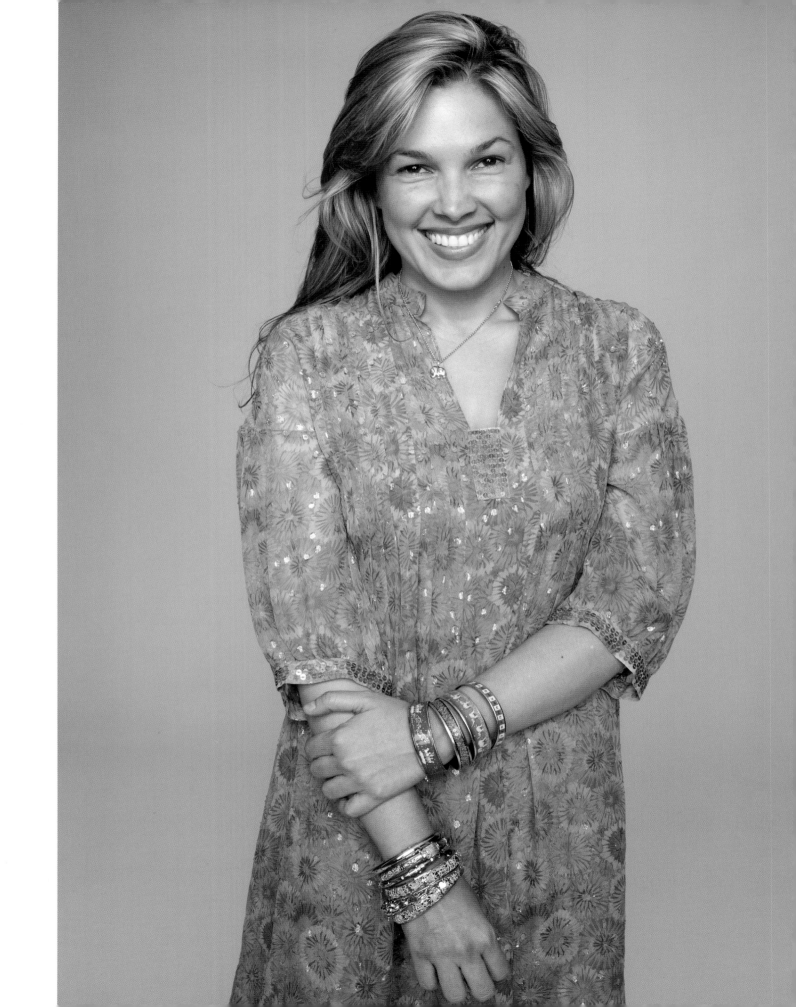

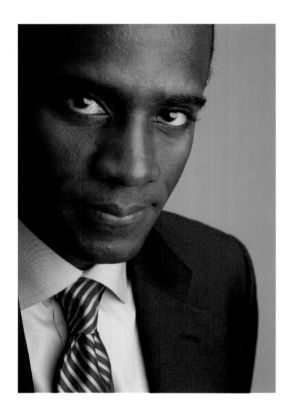

Pierre

My parents left Haiti for Zaire, a move to escape the political oppression in my birth country. Ultimately, we came to America, where I attended public schools before reaching the American Dream of an Ivy League education. I studied art history and mechanical engineering, before getting a Master's of Architecture degree. Today, I have my own architectural firm, a beautiful wife, and three wonderful American-born children.

Renan Pierre/Architect/Africa, Haiti

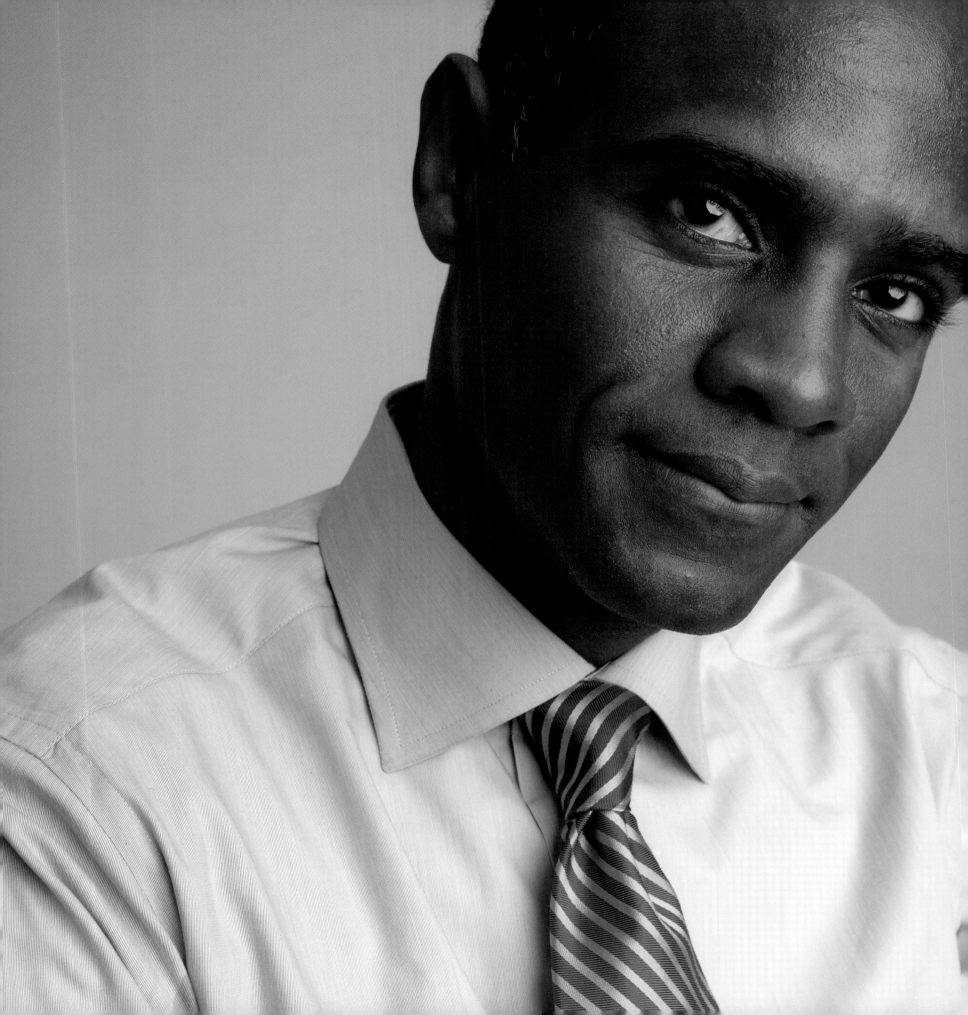

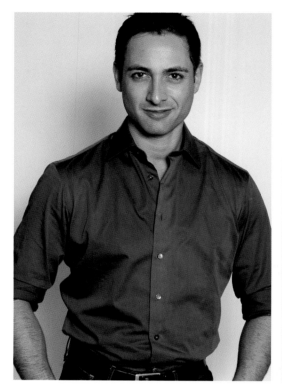 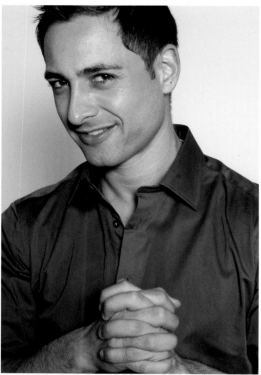

Coraggio

I'm a third-generation New Yorker and have never lived anywhere else! I studied physical education and then moved to life-coach training, where I work with busy New Yorkers in the worlds of entertainment and fashion. My American city is filled with diversity, energy and endless possibilities!

Louis Coraggio/Life Coach/Germany, Italy

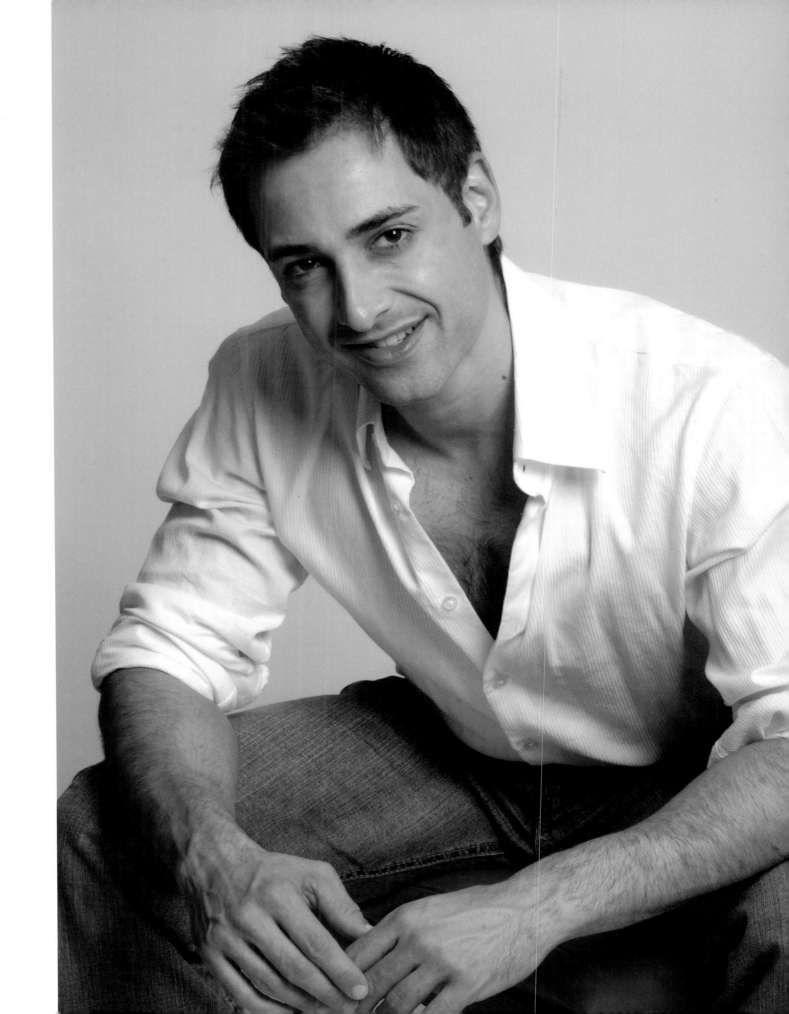

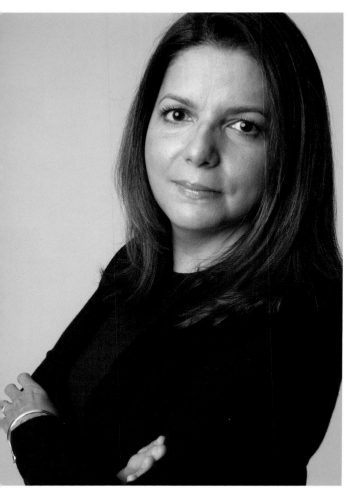 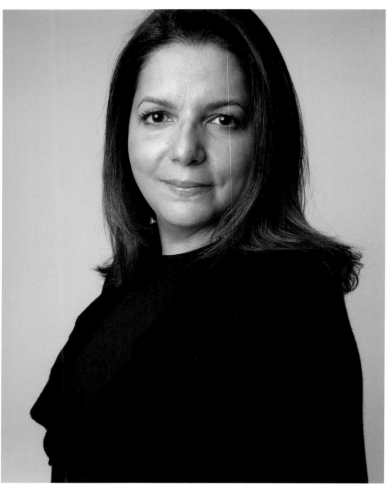

Calvey

I was born in America, but my entire family comes from the Dominican Republic. We were related to the president of our homeland, but my parents came to the United States in the 1950s. While my four siblings were born in the Dominican Republic, I was born in the United States. My one-hundred-percent Irish background husband and I visit the Dominican Republic every year, but America is our home.

Mary Calvey/Director of Special Events/Dominican Republic

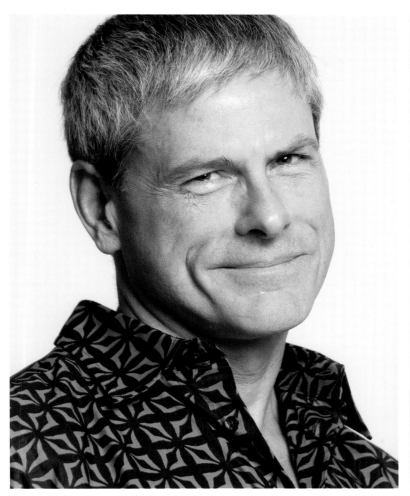 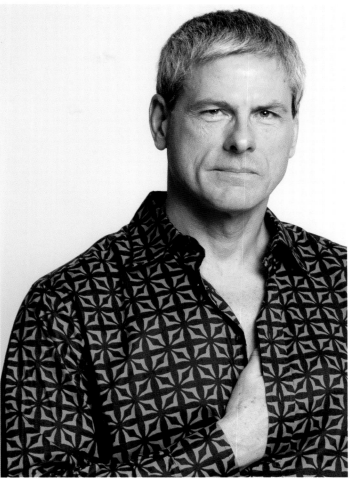

Schulz

Like many Europeans, all of my grandparents came through Ellis Island, from Prague, Bavaria, Northern Germany, and Canada via Czechoslovakia. My parents were born and raised in Washington Heights, New York, in a neighborhood in Manhattan that was the ultimate melting pot of European immigrants. New York is the city of my birth, but I now live outside of the city, practicing my craft as an architect.

William A. Schulz/Architect/Czechoslovakia, Germany

Haskell

When I first came to New York, I only knew one person living there, from Istanbul. What I learned is that in America I could become whomever I wanted to be, not only someone's daughter or wife, but myself. Something told me that America is where I belong and it has now become my home country.

Sule Haskell/Real Estate Broker/Turkey

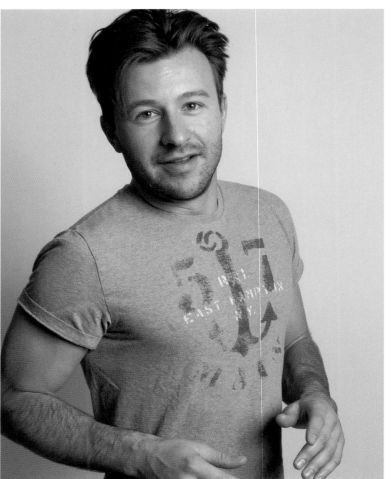

Hunt

I'm originally from Davenport, Iowa. My father's family came to Norfolk, Virginia, from Sussex, England, in the early 1600s, migrating west to Tennessee, Kentucky, Indiana, and ultimately Iowa. My mother's Norwegian and English family had moved to Iowa three generations earlier. As a poet and a writer, I am influenced by my deep American roots.

Lucas Hunt/Author/England, France, Germany, Norway

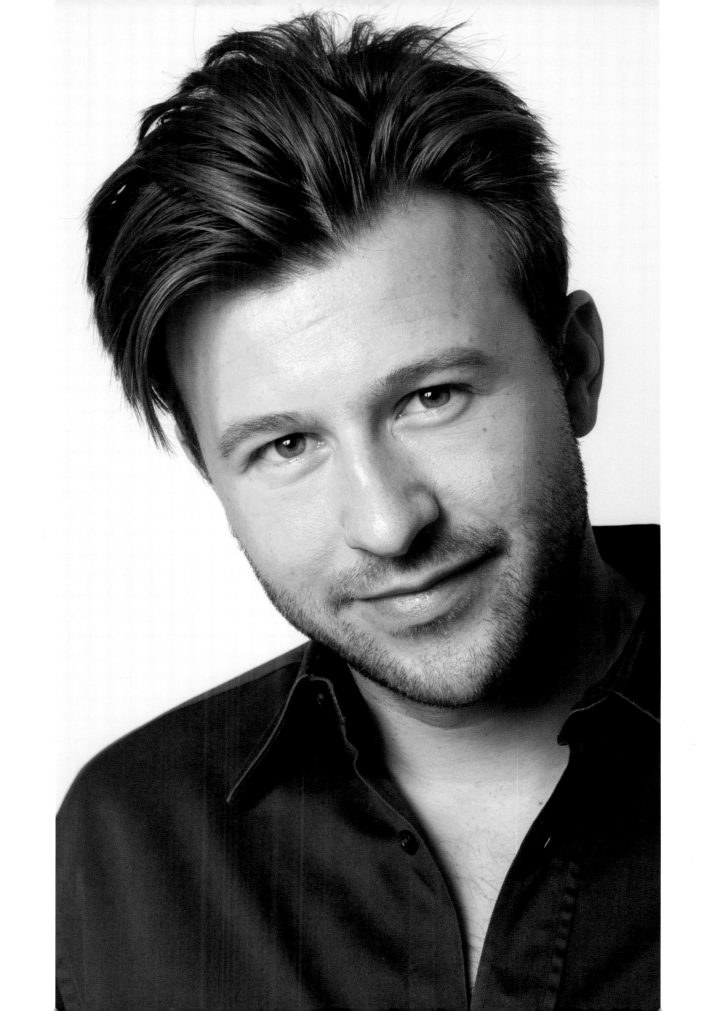

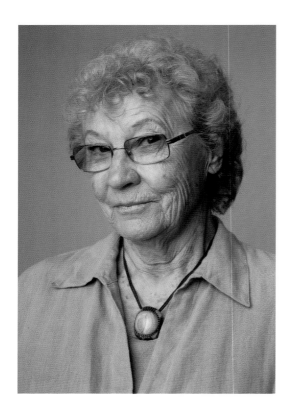

My parents moved from Germany to then Southwest Africa, after their wedding in 1929. I was born on a Namibian Persian lamb farm and grew up there, until I left for Germany to attend high school. While there, I met my American husband, got married, and moved to the United States. In 1961, I became a citizen and have raised two daughters here. I still return to Namibia as a volunteer teacher.

Christa Weigmann/Retired Elementary School Teacher/Germany, Namibia

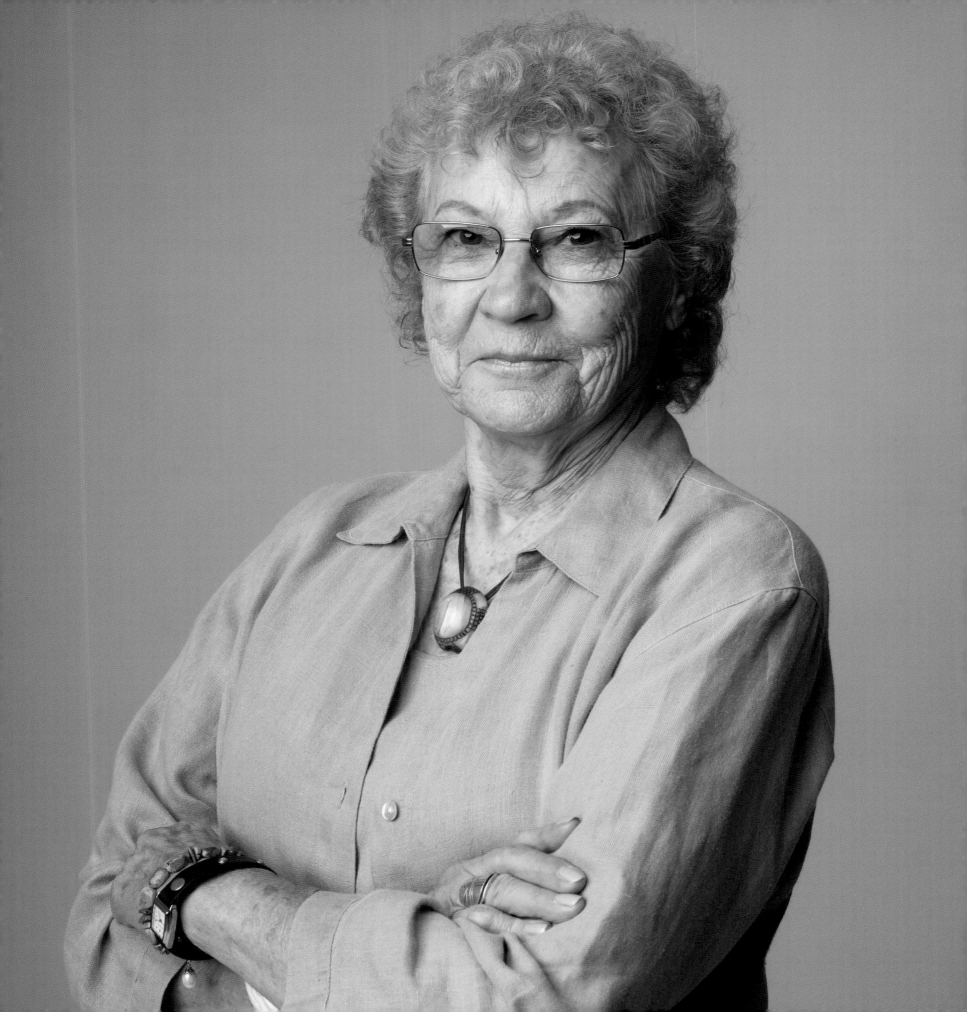

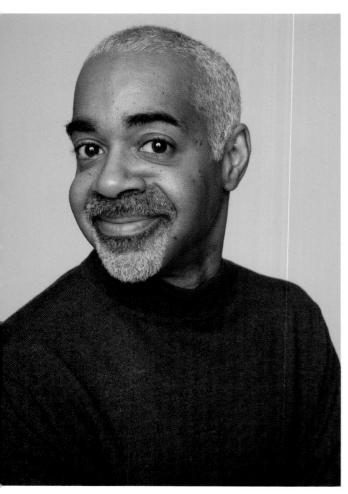 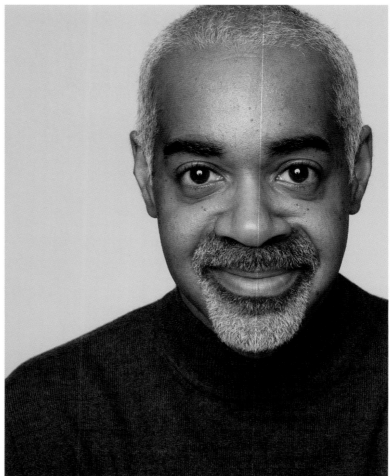

Scott

I was born in Brooklyn, New York and have never visited any of my countries of origin. But some of my background influenced my early career as a bass violinist and composer, before I moved to acting as my chosen profession.

Lorenzo Scott/Actor/Barbados, Belize, East Indies, Jamaica

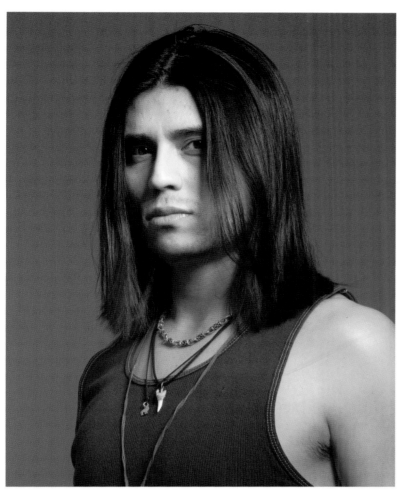 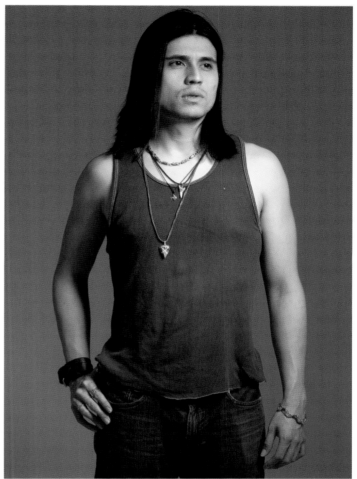

Moreno

My grandparents are from Bogota, Colombia, and when my grandfather came here in the 1950s to study engineering, he ended up staying, ultimately bringing my father, his two siblings and his wife to begin their American journey. My parents are both Colombian, meeting here. My father did become an engineer and my mother is a painter and a sculptor.

Ron Moreno/Actor/Colombia

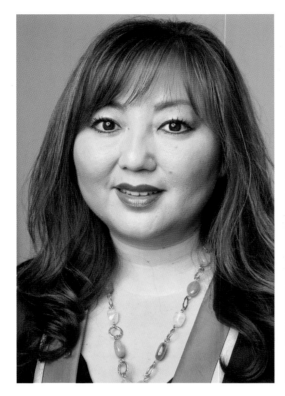 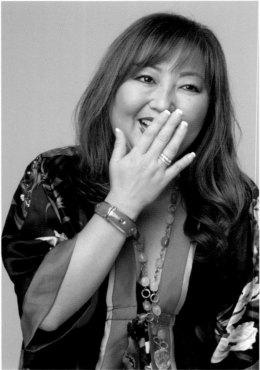

I was born in Seoul, Korea, but as a youngster my parents moved to Chicago with their three young children, so that we could be educated in America. Although I still have strong ties to Korea and have a large family there, my parents have taught us to become responsible citizens to our new country, one that I love.

Christina Krolopp/Media Sales Manager/Korea

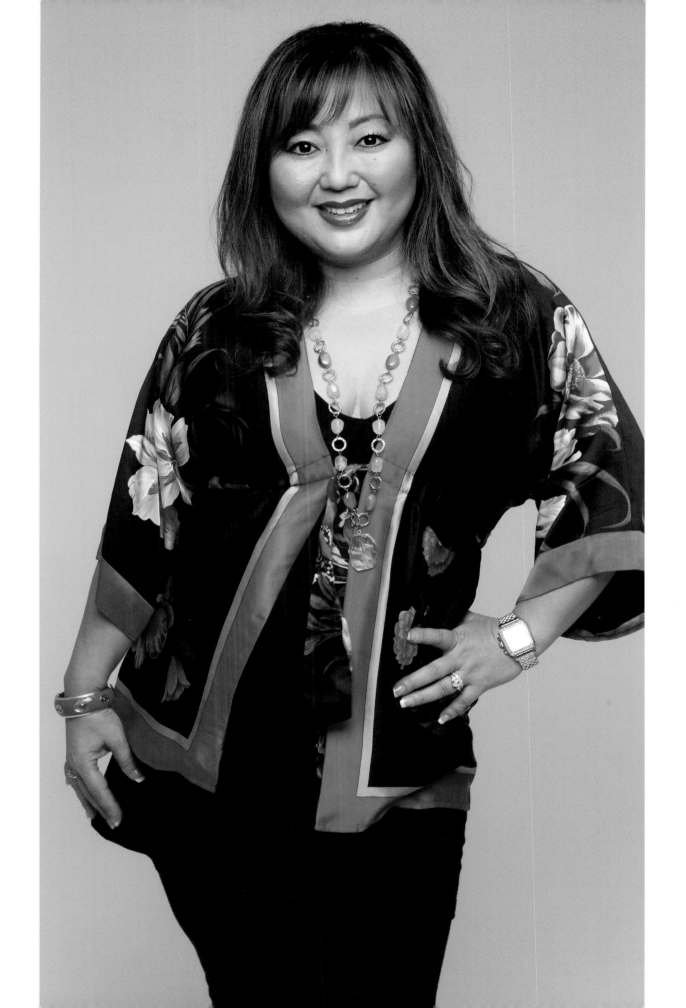

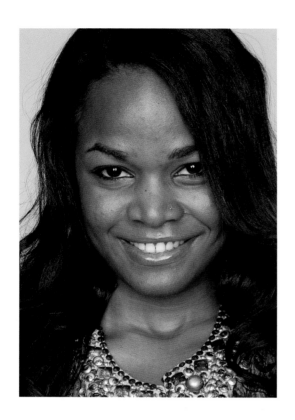

Huggins

My mother was one of five children raised in Nassau and was the only one who came to America to work for the International Monetary Fund in Washington, D.C. My father is from Nevis, but it is the Bahamian culture that I am closer to, since we visit our family at least twice a year. And while I appreciate my heritage, it is America that I call home and where my future opportunities lead me to my future goals as a marketing and advertising professional.

Bronwyn Huggins/Marketing and Advertising Professional/Bahamas, Nevis

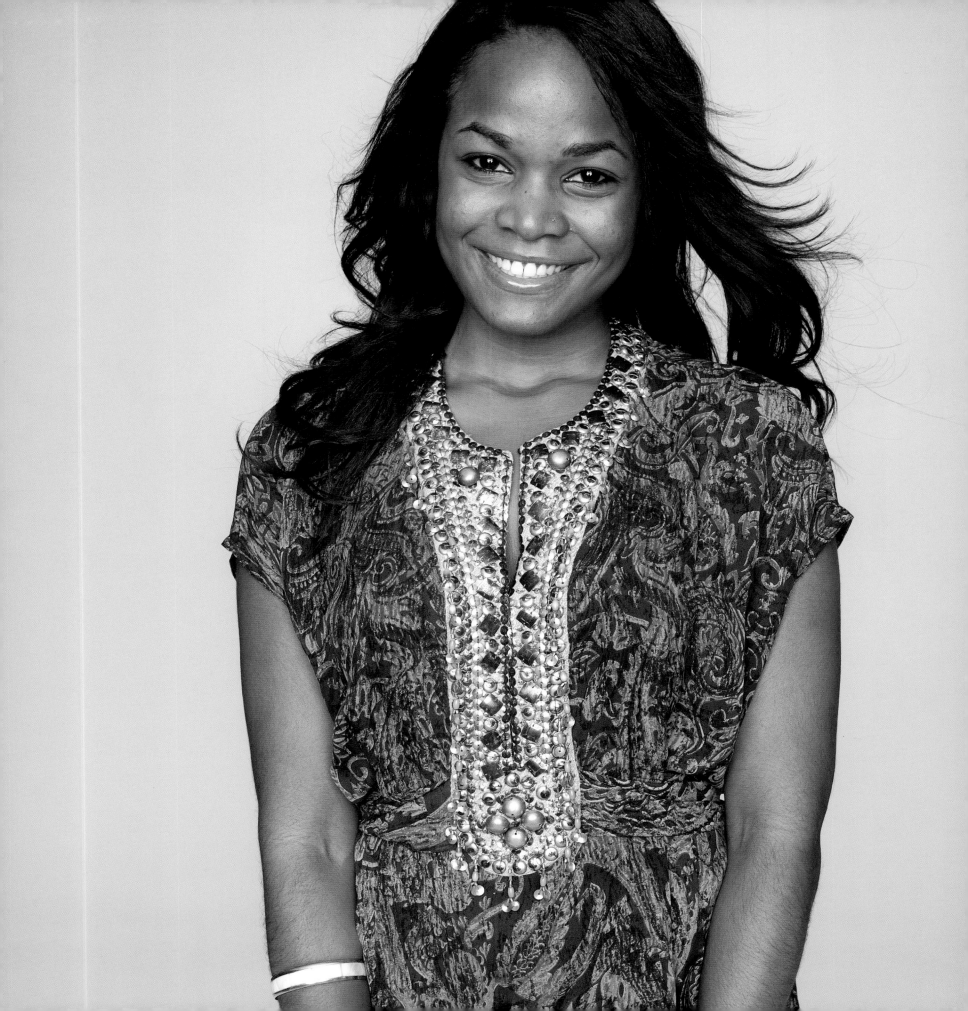

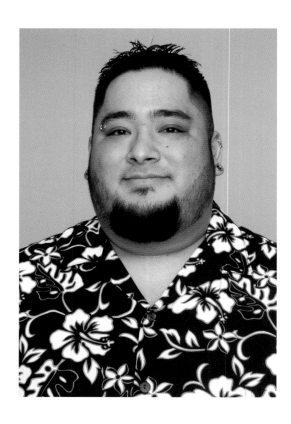

I was born in Maui, Hawaii. My maternal and paternal great-grandparents and grandparents came from Portugal and Japan to work in the sugar cane and pineapple fields. My parents both became teachers and it is my father's love of music that has inspired me to pursue a career in that world.

Kurt Jo/D.J. , Model/Japan, Portugal

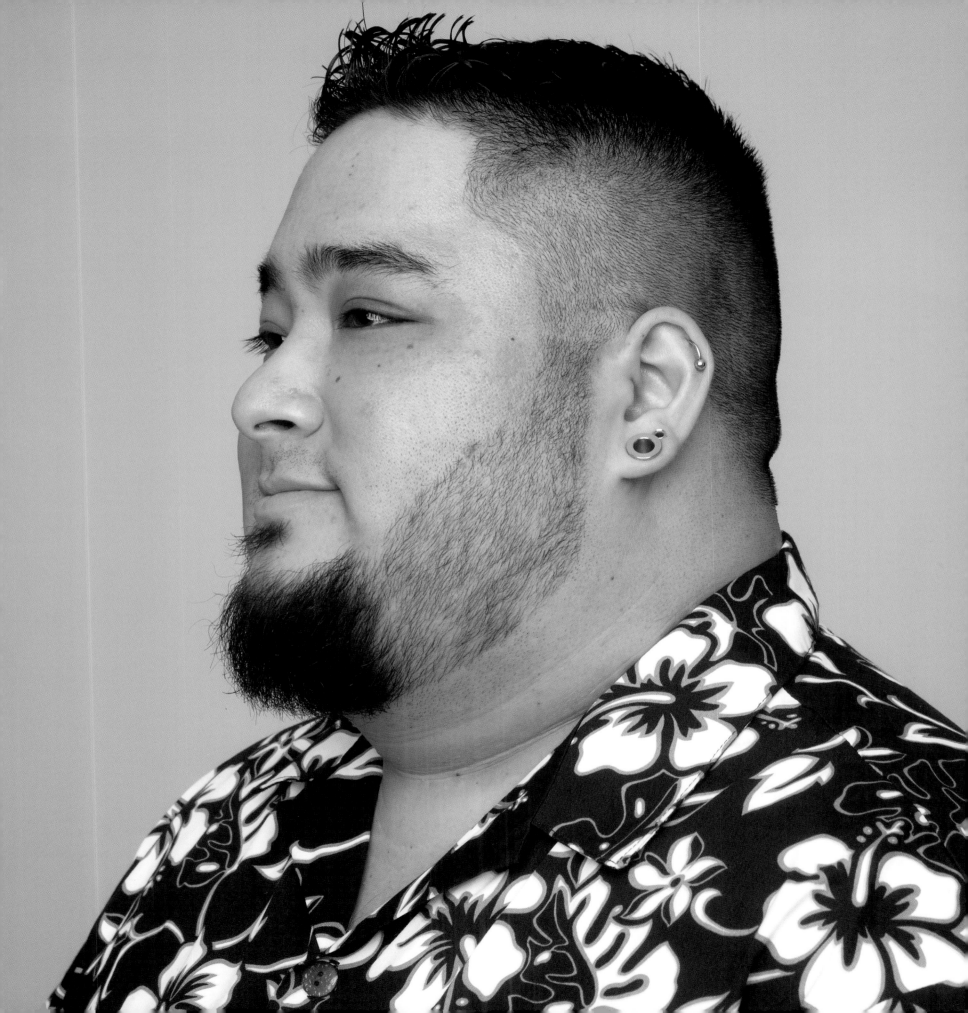

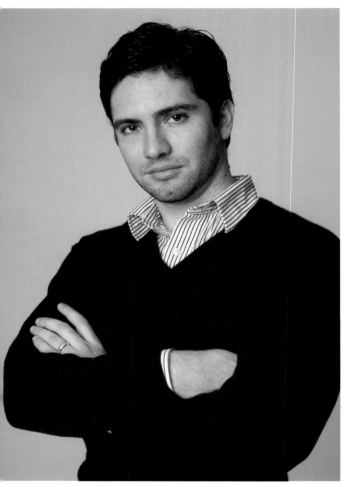 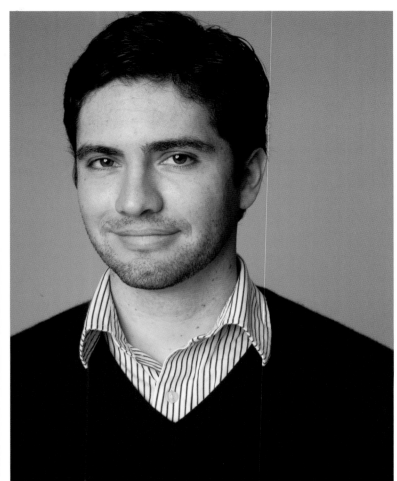

I was born and raised in Chile and it was my great fate to fall in love with an American, who was in South America for a college junior year abroad. We had a long-distance relationship for awhile, but decided to get married. When she was accepted to law school, I went to Boston with her and will join her as an American this year.

Diego Valdivia/Social Investment Fund Manager/Chile

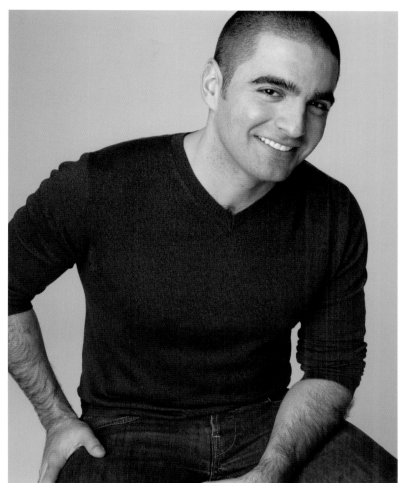 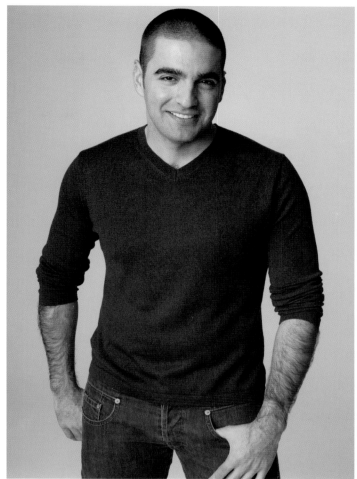

I was born an American citizen in Panama City, Panama and came to study industrial engineering and to attend graduate school in business. I stayed in America because of the amazing career opportunities and lifestyle freedoms that we have in our country, and I've had the good fortune of living in many different cities to see the many sides of America.

Alejandro Villageliu/Consultant/Cuba, Panama, Spain

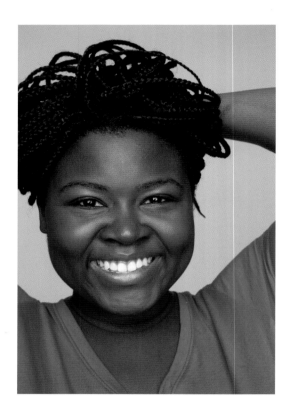

My four siblings and I were born in upstate New York, children of two African-born parents who met while they were studying at an American university. Both of my parents are citizens now, and I have been to Malawi once to visit the homeland of my mother.

Chengusoyane Kargbo/Assistant House Manager, Actress/Malawi, Sierra Leone

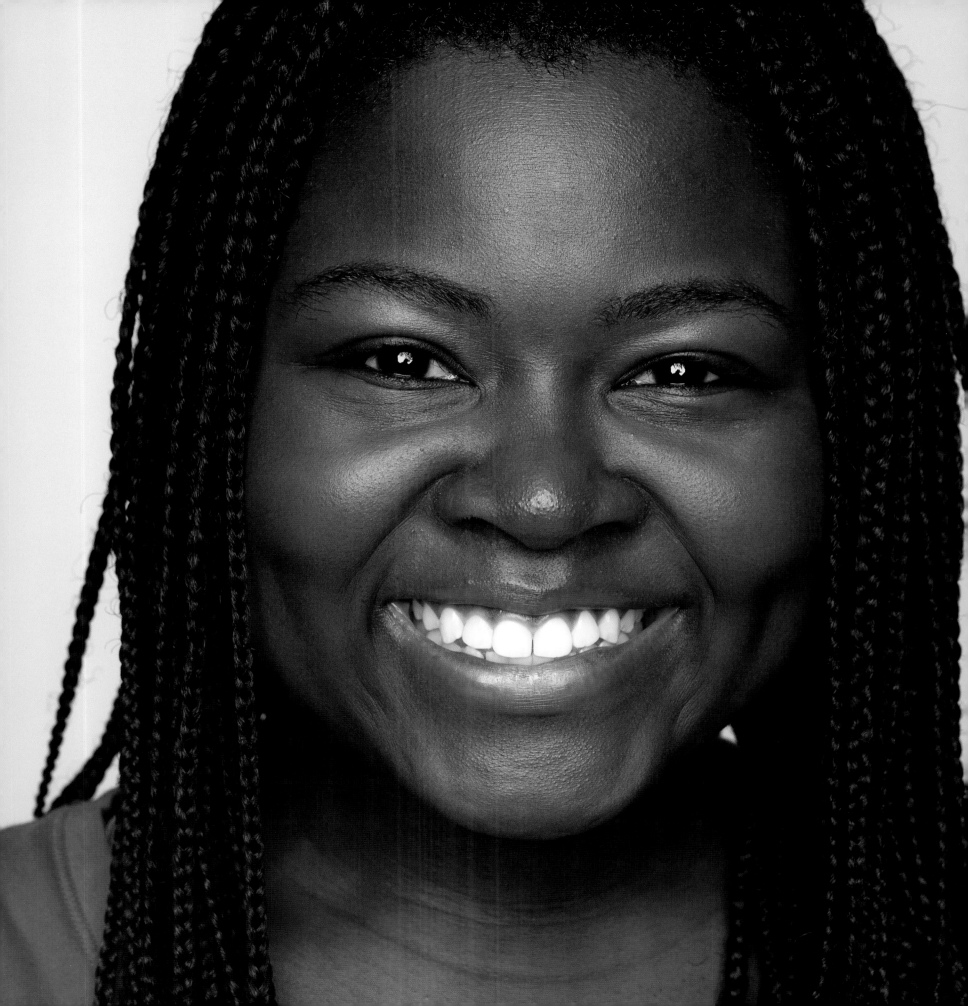

Both of my parents were born in the Azores, Portugal, but left in 1969 to find a better life in America. I was raised in a Portuguese-American community and pursued my own American Dream, attending American college and medical school. I have my own private practice in gastroenterology and while America is my home, I hope to raise a bilingual daughter, who can speak to my Portuguese family in their native tongue.

Paulo Pacheco/Gastroenterologist/Portugal

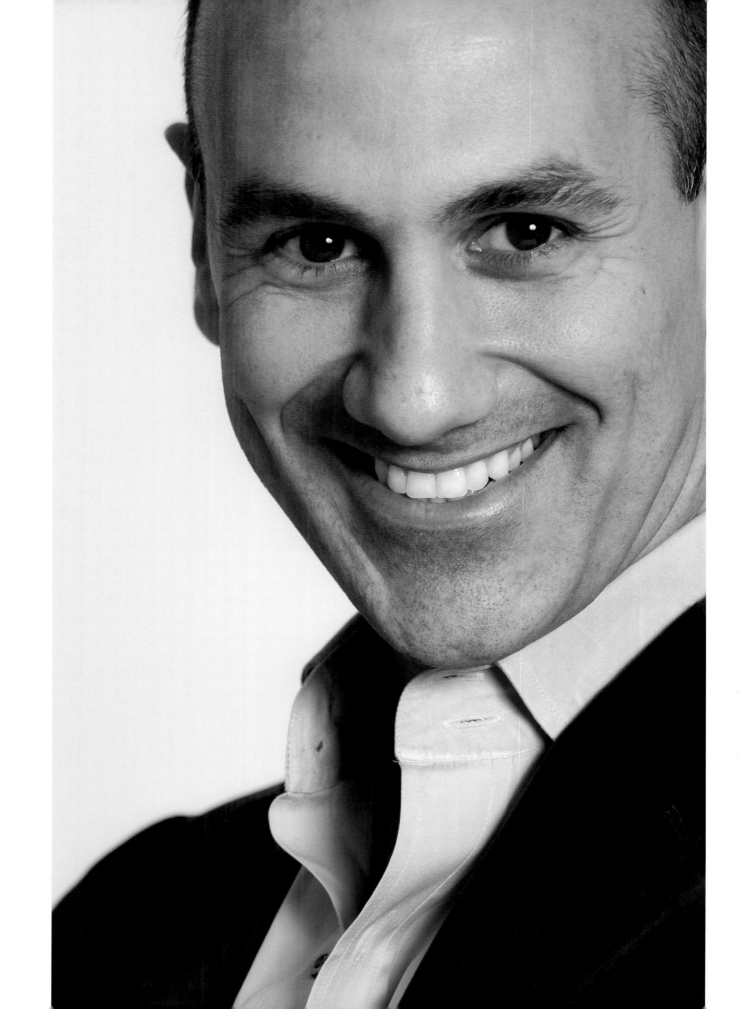

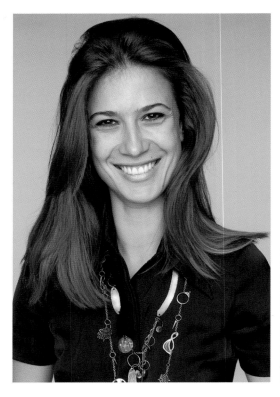 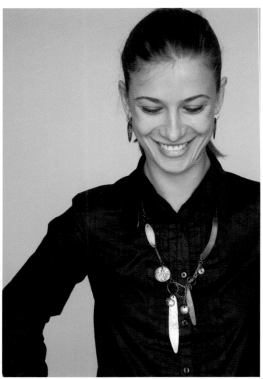

Djuric

I first came to America as an au pair for an American family. Once I was here, I decided to study jewelry design and fine art and, ultimately, met my American husband of Irish and Hungarian descent. He is a photographer with whom I've worked on numerous international assignments. My family is still in Serbia, although my brother has just come to America to live.

Jovana Djuric/Artist, Jewlery Designer/Serbia

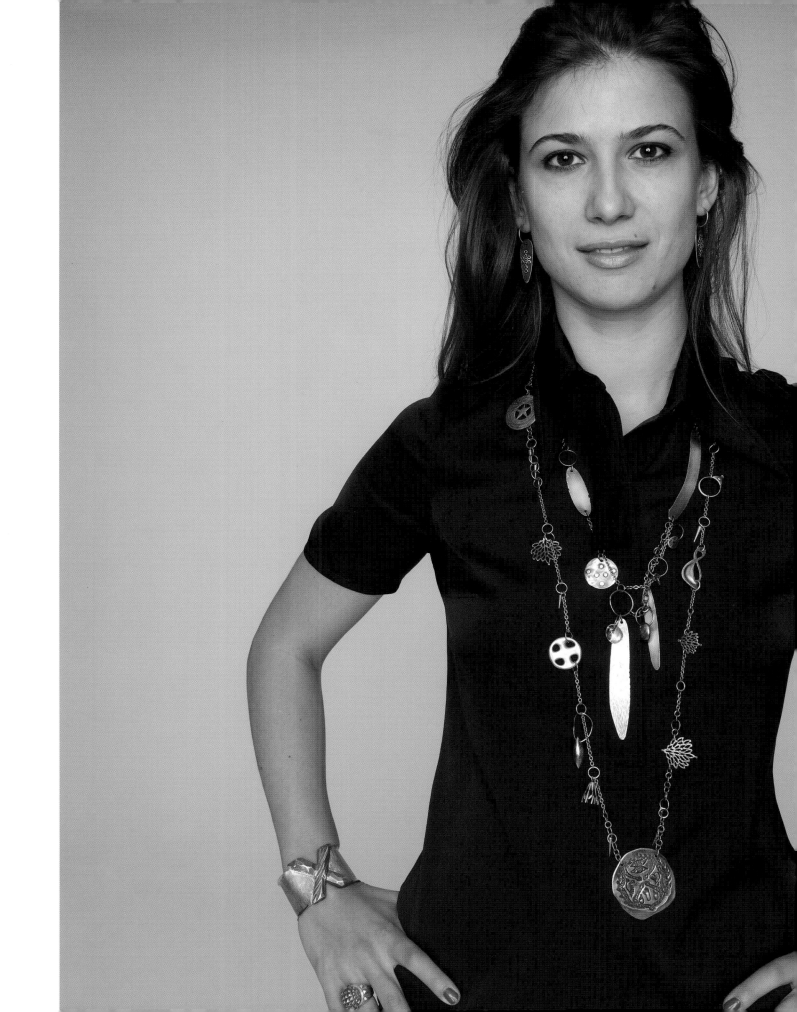

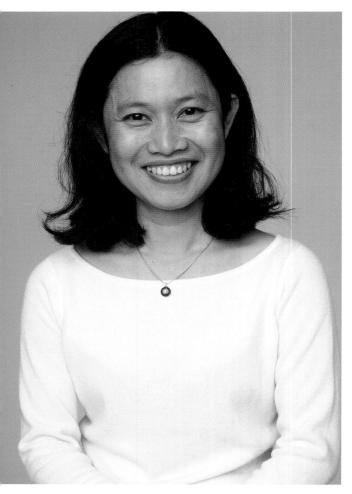 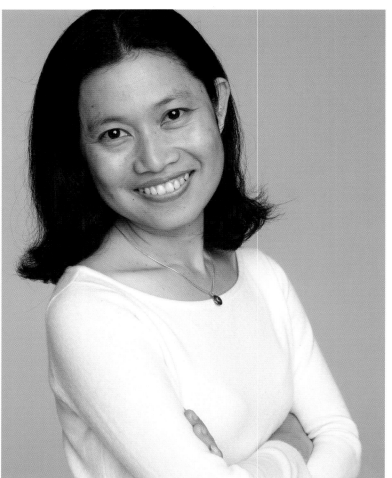

I first came to America to attend film school and worked as a part-time waitress in a Thai restaurant, where I met my Thai husband, who was a customer. We decided to stay in America to raise a family and while I speak Thai and love my birth country, I have not returned there since I came to the United States almost fifteen years ago.

Angkhana (Katie) Chermsirivatana/Floral Designer/China, Thailand

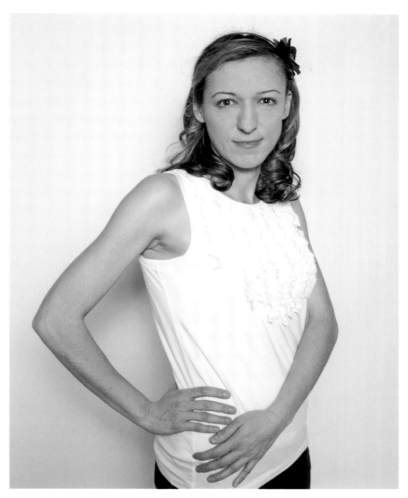 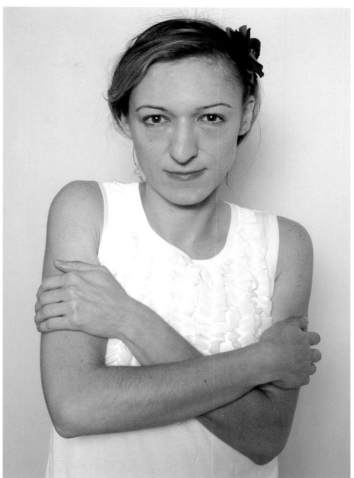

Acosta

My mother was on her first trip out of the United States, visiting Cuzco, Peru, when she met my father and never left the country. My mother and I left Peru after my parents divorced, settling in Germany for a few years. My father, an architect, stayed in Lima. But I returned to my homeland for college and veterinary school and now work in a private veterinary practice.

Chantal Acosta/Veterinarian/Germany, Norway, Peru

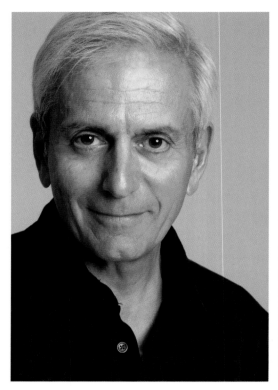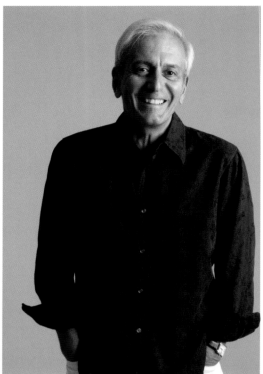

DeVincentis

My paternal grandfather came to America to play baseball for a team in Pennsylvania, and ultimately settled in Ohio to start a small business. My mother was born in Massachusetts, but also moved to Ohio, where they met and raised three sons. I stayed in my home state to attend veterinary school, but moved East to start my own private practice, which I wrote about in my book, *Tails of the City*.

Tom DeVincentis/Veterinarian/Italy

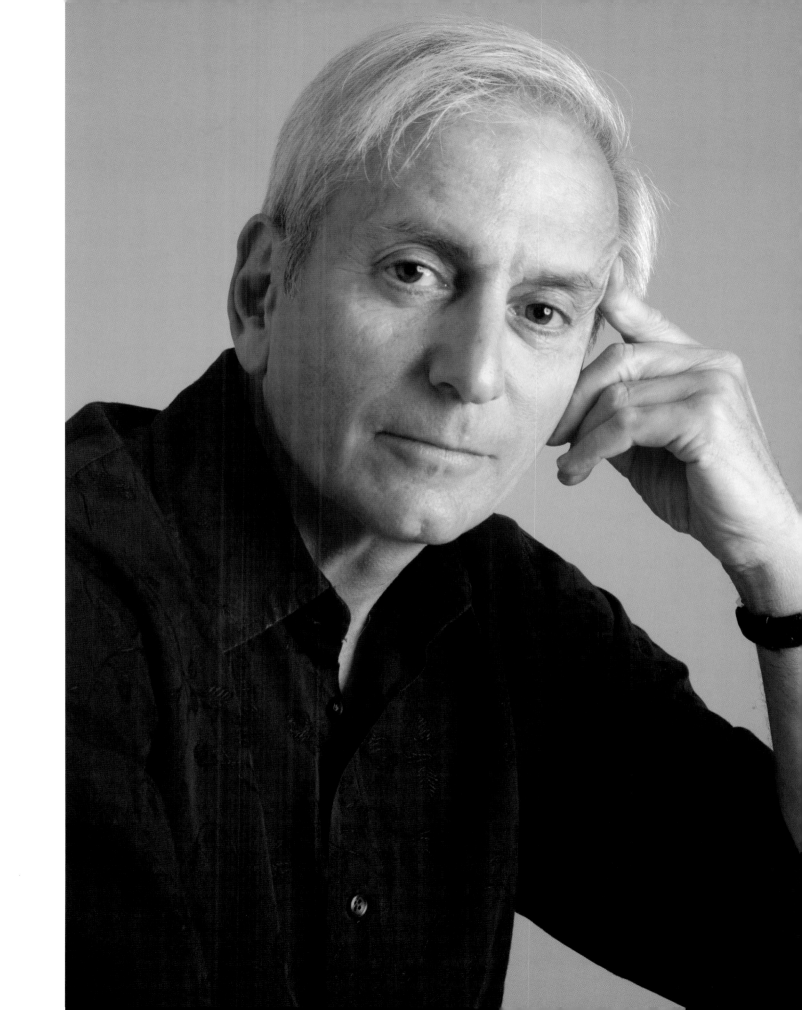

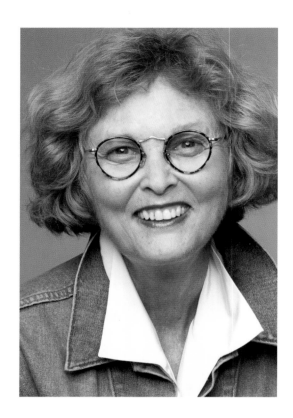

My father's parents, Daniel Olsen and Ingaborg Anderson, left Norway and entered the United States at Ellis Island. Before heading to northern Minnesota, land of many Olsens, the clerk agreed to change their name to Rolland, named after their hometown region in Norway. My mother's parents arrived from Sweden and their name was shortened from DeBramme to Bram. As a second-generation American, born in California, I am grateful to the Ellis Island clerks, or my name could have possibly been Ingaborg Olsen!

Mary Rolland/Artist/Germany, Norway, Sweden

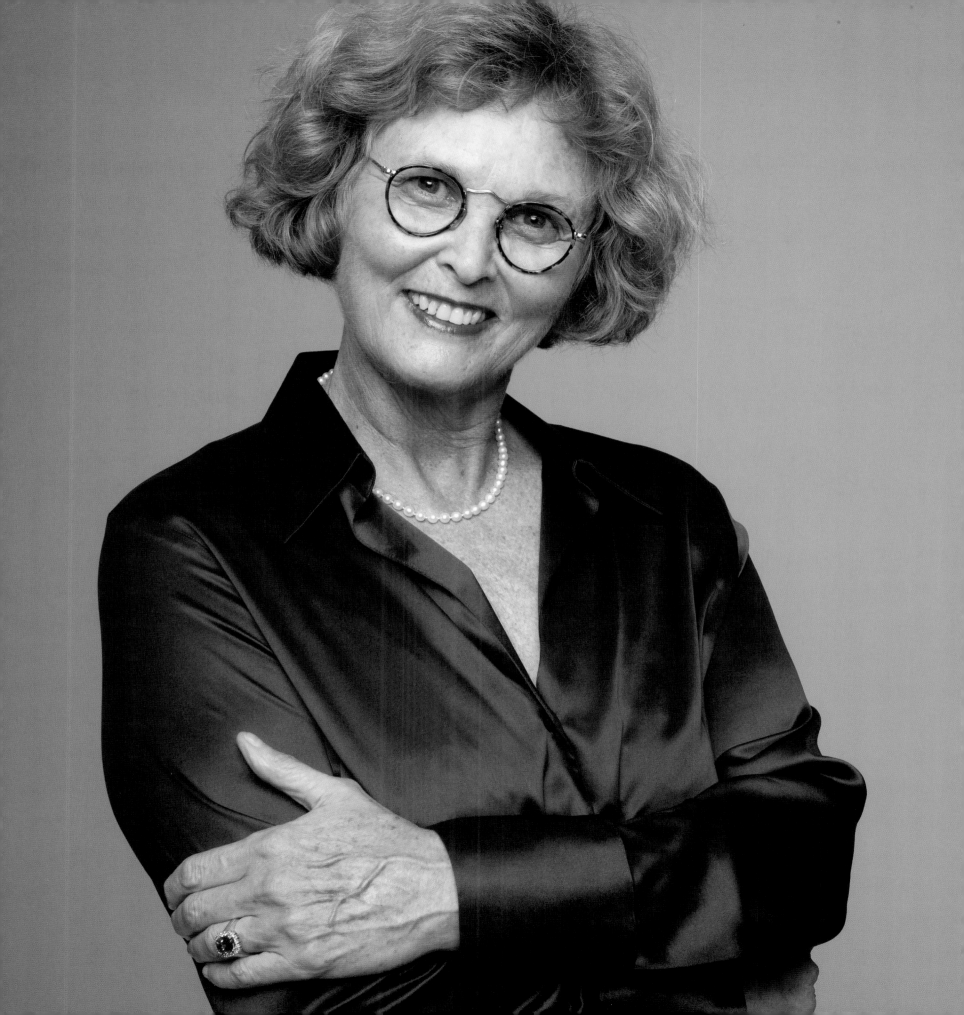

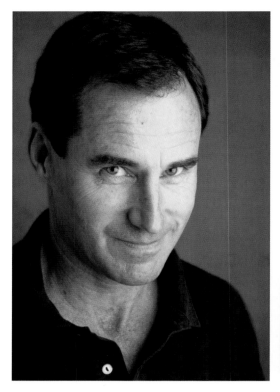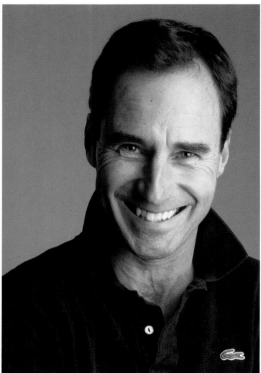

O'Malley

I'm a fourth-generation American coming from a long line of big Irish and English/Welsh families. My parents were one of eight and six siblings, respectively, and I am one of nine brothers and sisters. Both of my grandfathers served in the two World Wars, one as a volunteer in the ambulance corps in France during WWI and the other as a colonel in the United States Army in WWII, each serving to defend America. My great-grandmother became one of the first practicing female lawyers in Pennsylvania. Today, my wife and I are raising four sons, with the goal of instilling many of my family's values into their lives.

Kevin O'Malley/Publisher/England, Ireland

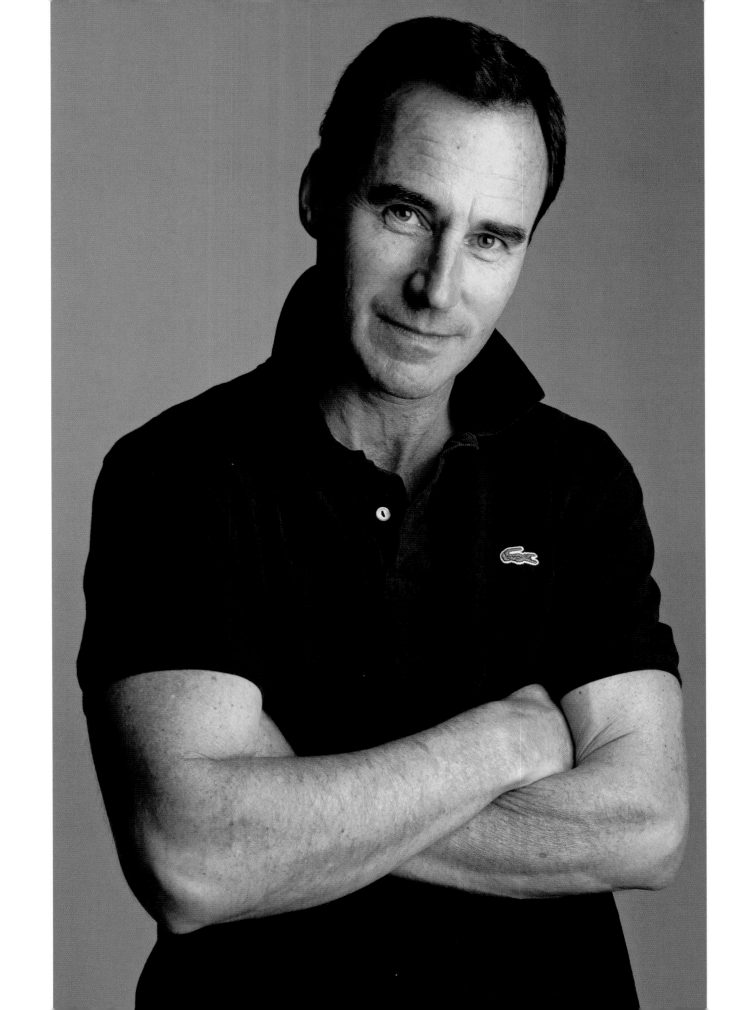

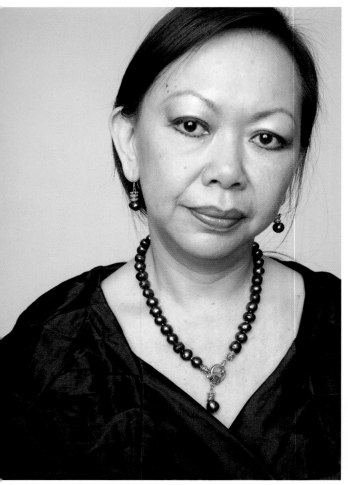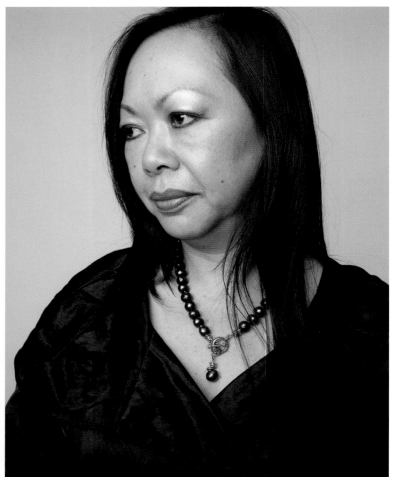

I grew up on a rubber plantation in Malaysia that was owned by my grandparents. When I was eighteen, my family emigrated to Australia, and from there I went on my own to live in Saudi Arabia, then Pakistan, and then London. More than twenty-five years ago I arrived in America for a visit and felt instantly that I had "come home." Here I stayed, married to an American-born man with Russian and Lithuanian roots.

Jackie Chan-Brown/Real Estate Broker/China, Malaysia

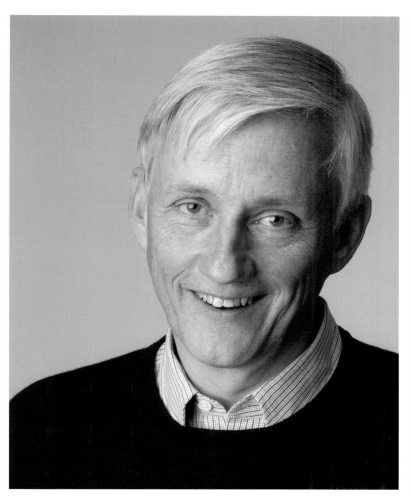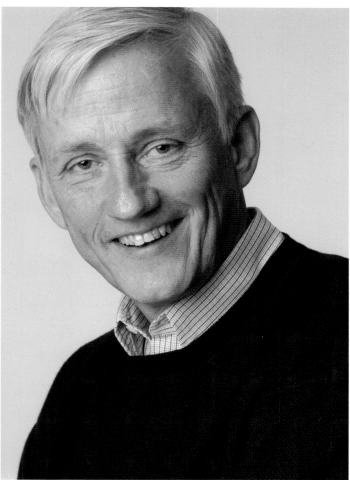

I was born in Eindhoven, Holland, to a family that included colonialists in the Dutch East Indies, as well as farmers of large tracts in Holland, whose business was dairy exports. My personal journey brought me to America to study, where I fell in love with America and an American, married, and had two children.

Willem F.P. de Vogel/Investor/East Indian, Netherlands

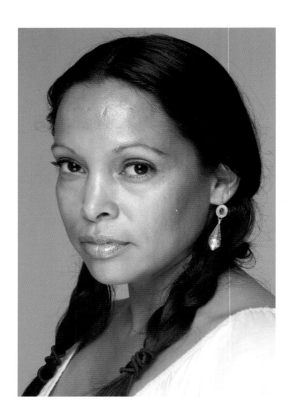

Spink

My father's family is from the oldest continually lived-in village in the United States, located on the second mesa, so we are an indigenous family even before America was formed. My mother's family came here several generations ago from the North of Scotland, where they were originally shipbuilders. My ancestry is Hopi Indian, along with other strains of American Indian and we have a long oral history of our family's beginnings.

Rolise R. Spink/Fashion Retailer/Hopi, Netherlands, Scotland

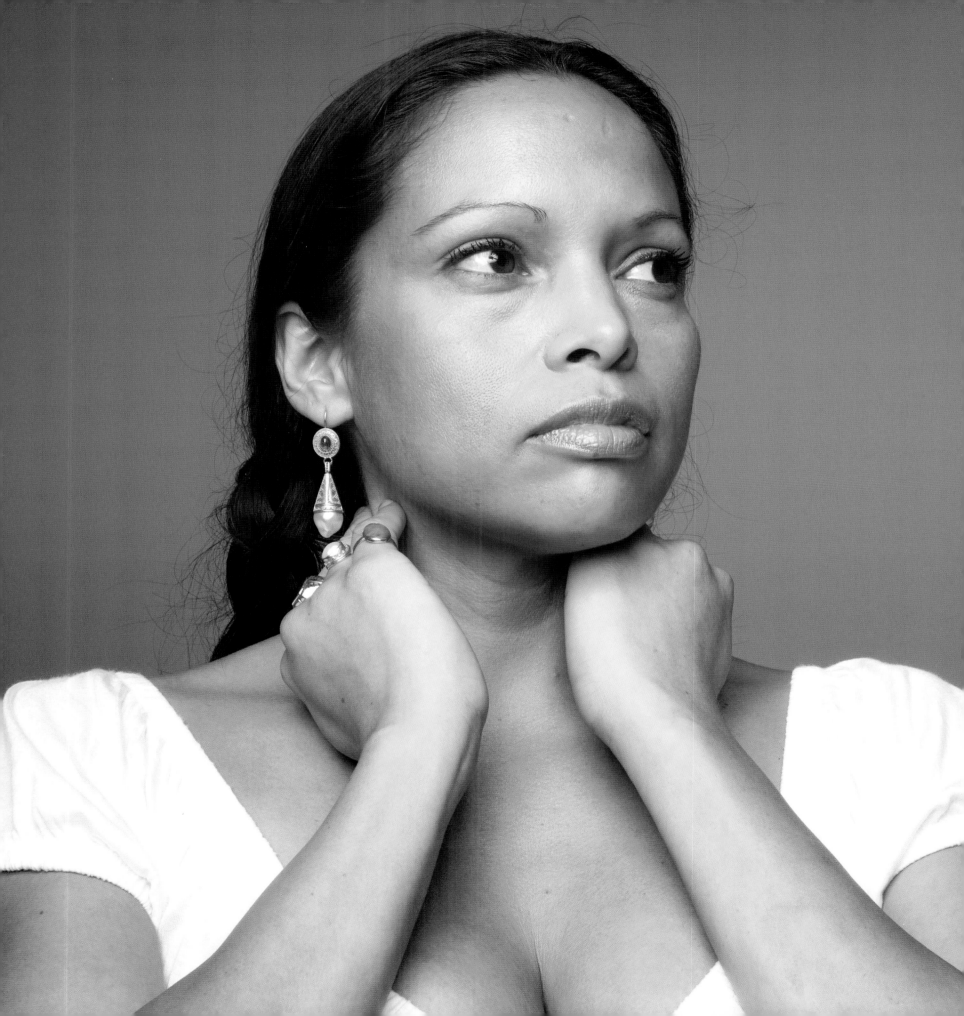

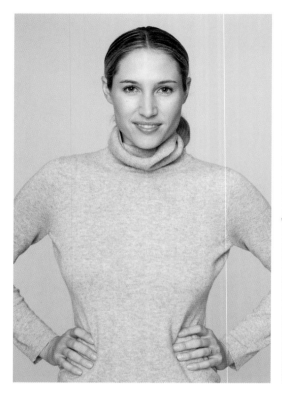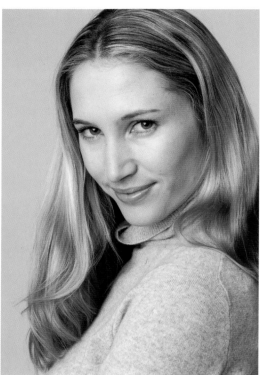

My parents have a ranch in Australia, where I was born. I decided not to make my life in Australia, but instead to come to the United States to study fashion. My intention was to return Down Under, but fell in love with an American and decided to spend my life here, where I have worked in the publishing, advertising and photography worlds. In 2009, our new son will take his first trip to Australia. What I've learned is that once you live in America, it's hard to live anywhere else.

Allison Brokaw/Producer/Australia, England

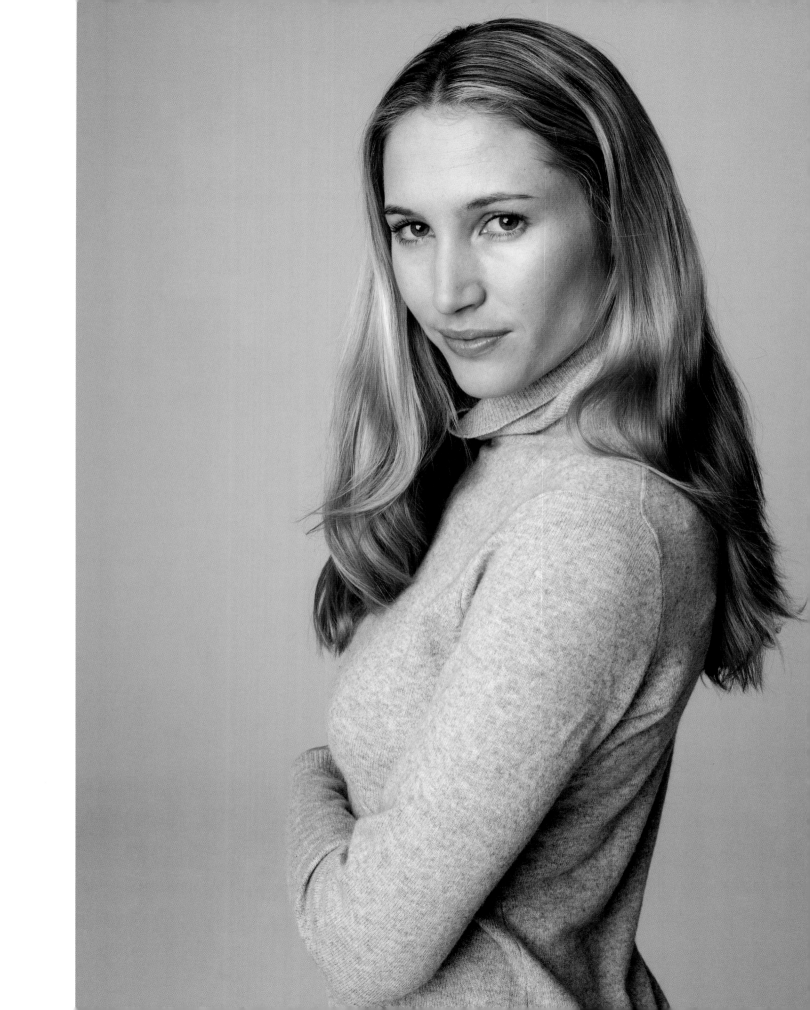

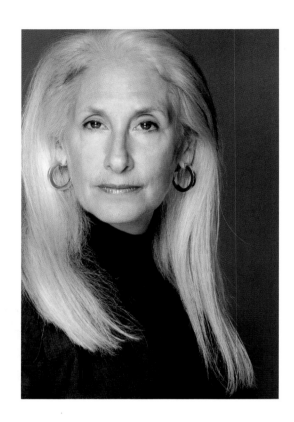

My father's family has been in America for over one hundred years. He was one of four brothers, all of whom lived the American Dream, attending college and graduate school, and ultimately becoming professionals. My father chose law as his profession. My mother, the only child of immigrant parents worked as a paralegal for a judge. She met and married my father and ultimately together they had two children. I pursued my dream to become a creative director, a profession that I love, and my husband and I are the proud parents of a young medical doctor, the chosen profession of our only child and daughter.

Judith Bookbinder/Creative Director/Austria, Hungary, Lithuania, Poland

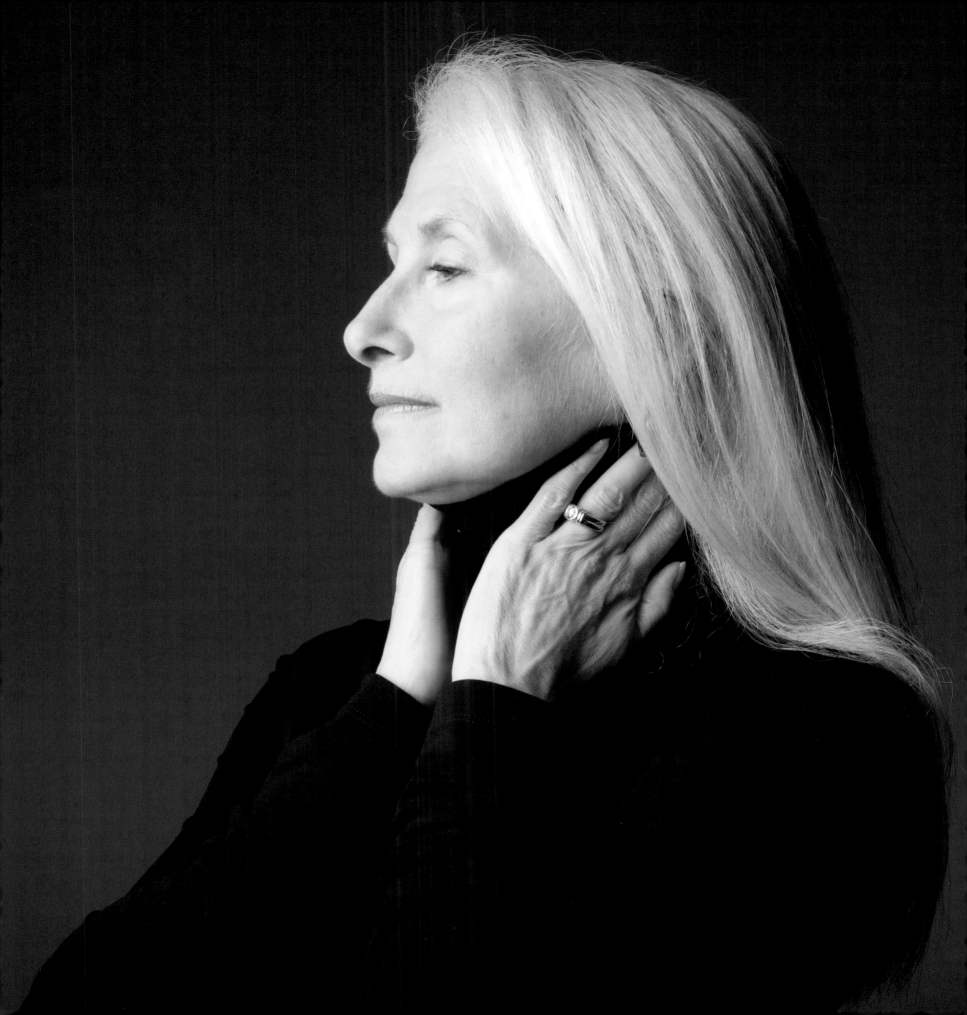

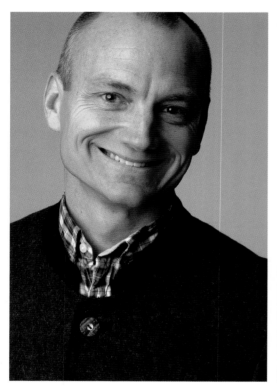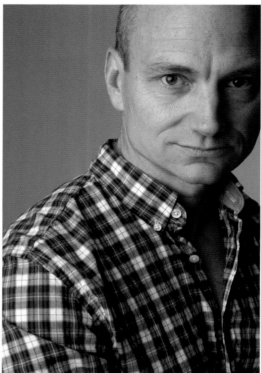

Usnik

I'm originally from the Midwest, a third-generation American from a working-class family. My goal was to attend college and graduate school, and I have ultimately worked in major financial service, media and cultural institutions. My American story is that I was able to create my own life, filling it with my own goals.

Toby Usnik/Corporate Communications Director/Austria, Netherlands, Slovenia

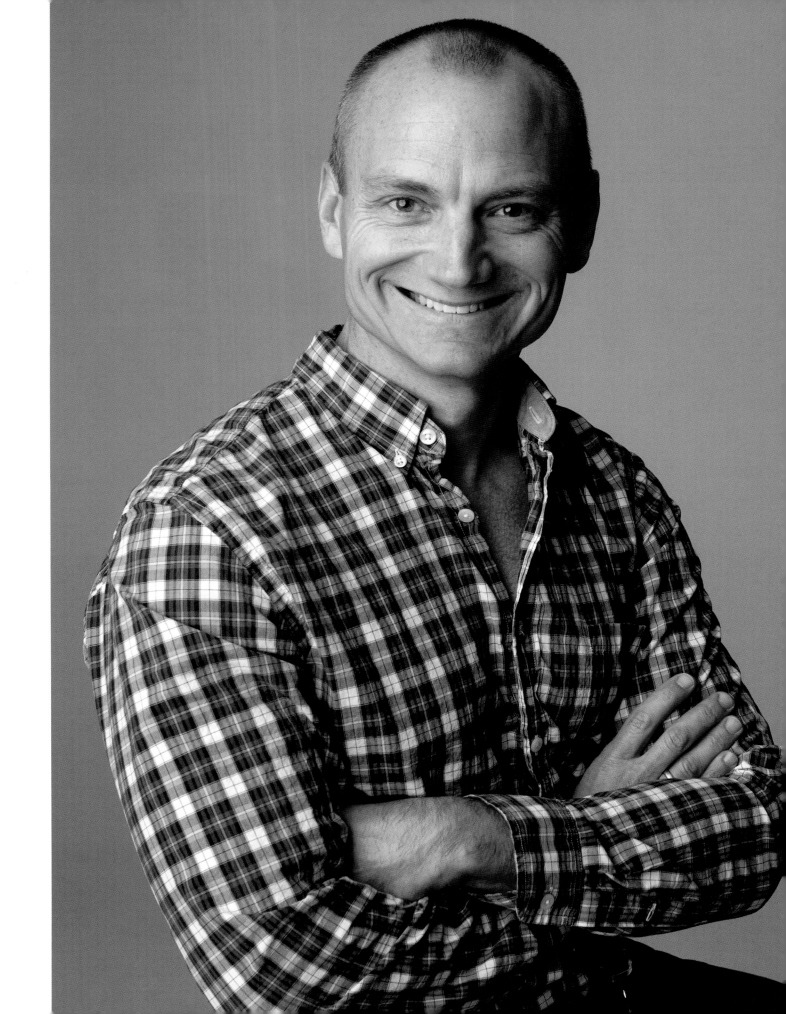

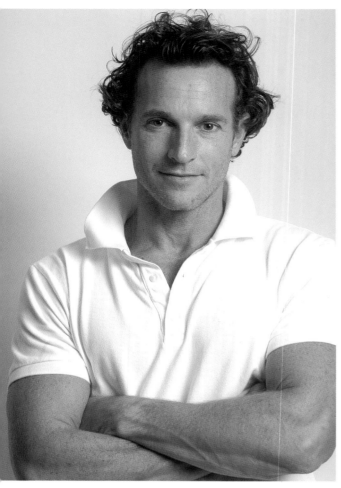

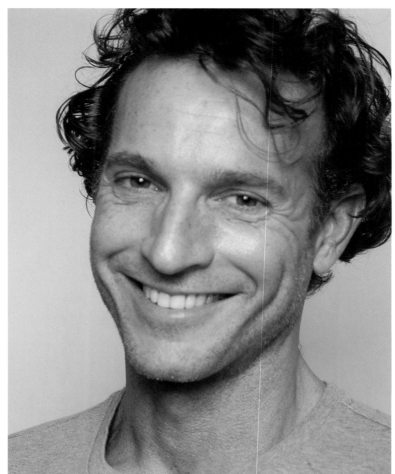

Kolasa

All of my mother's family came from different parts of Italy and my father's family was from Poland, Austria, and Slovakia. His parents arrived in America to the ethnic enclaves that existed here. My grandmother's ability to speak Slovak allowed her to gain employment as the Postmistress of Clarence, Pennsylvania, a job that she held for over forty years. My own journey brought me to the world of New York, where I have worked as a fashion executive for a number of major fashion designers.

George Kolasa/Fashion Executive/Austria, Italy, Poland, Russia, Slovakia

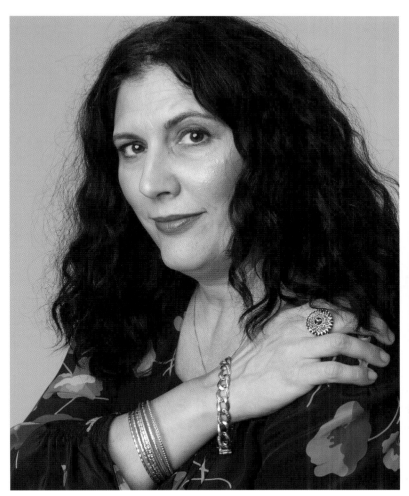

Peer

My family background is European, however my parents were born in Israel, and I was born there, too. We came to the United States when I was six years old and while I have some memories of living in Israel, it is great to be living in America.

Eydie Peer/Sales Associate/Austria, Czechoslovakia, Greece, Israel, Turkey

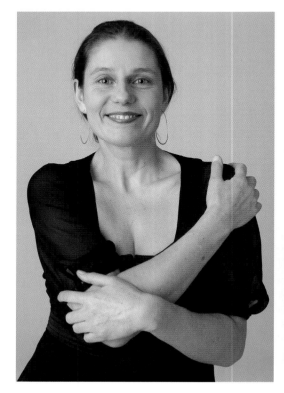 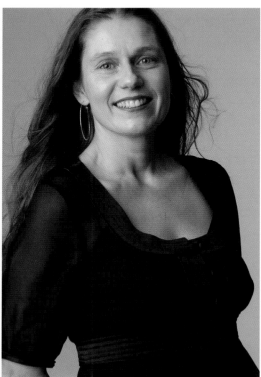

I first came to America from Zurich, Switzerland, to study photography. And while I thought that I might spend a few years here, once I arrived, I fell in love with America and Americans. In 2002, I became a citizen and now I work here as a photographer, as well as raise my American-born child.

Gabriella Imperatori-Penn/Photographer/Czechoslovakia, Italy, Switzerland

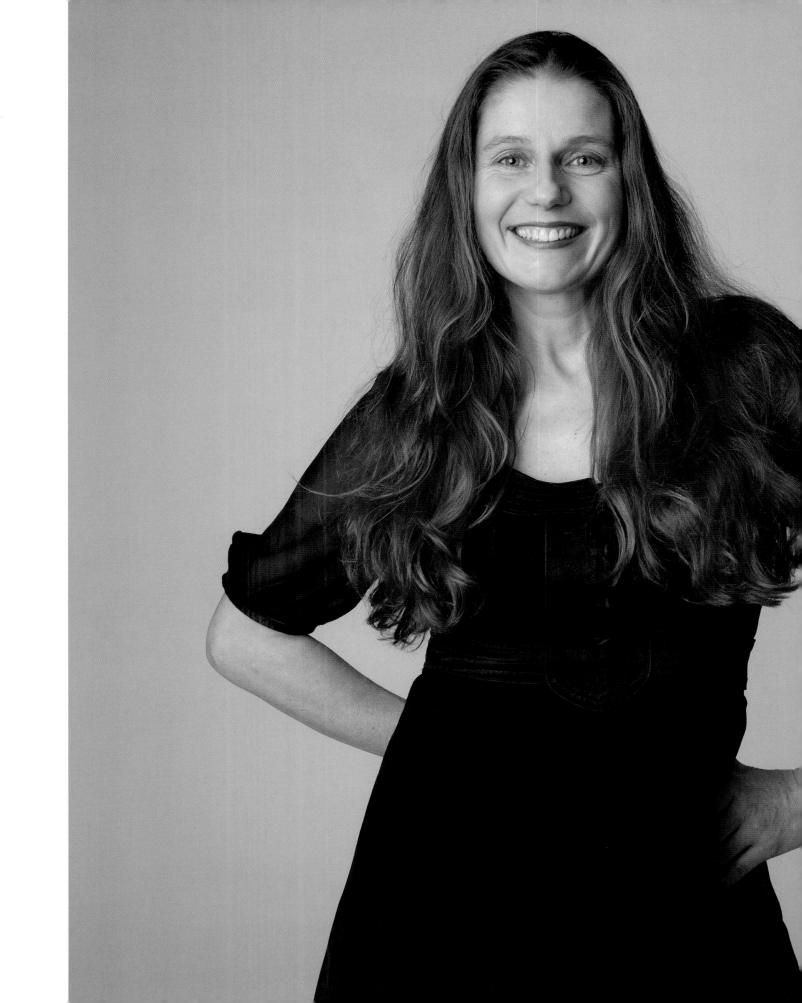

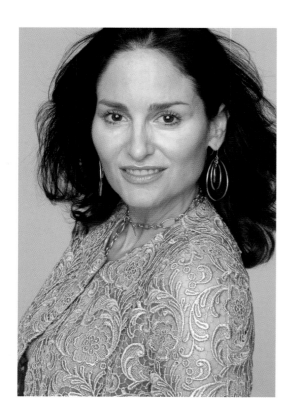

As a third-generation American, we have many bloodlines in our history. My two sons have added Scottish and Cherokee Indian to their backgrounds. Our family always had a great respect for the American Dream, especially with education and hard work. And we always believed that giving back to one's community is an essential part of the American way.

Kimberly Skeen-Jones/Artist, Producer, Fundraiser/England, France, Netherlands, Russia, Spain

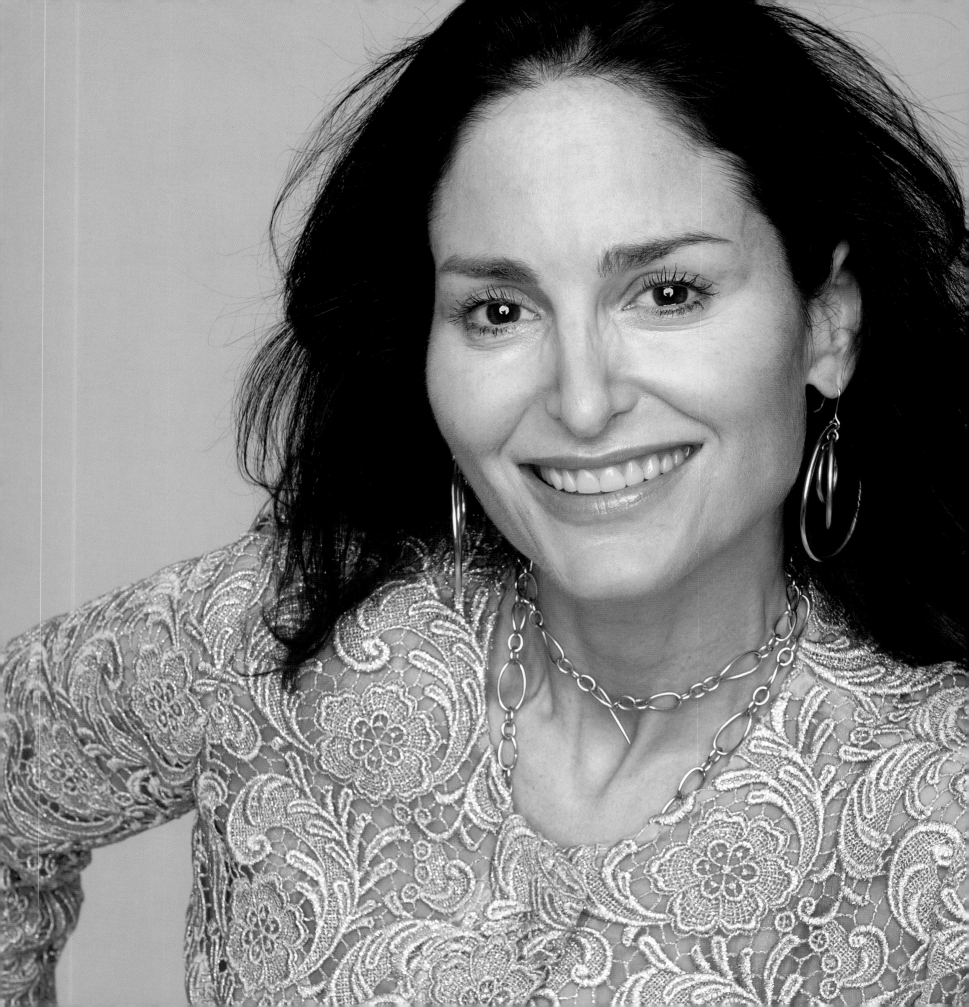

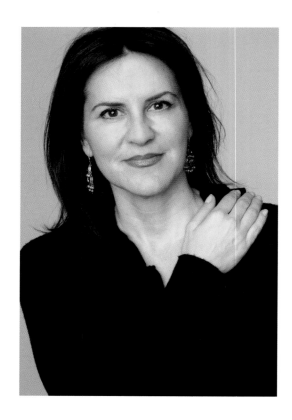

Soss

I'm a second-generation American from San Francisco, where I spent a large part of my life. Ultimately, I moved to the East Coast to work in the fashion industry, through which I have traveled the world, including an opportunity to visit the countries of my family's background.

Deborah Soss/Retail Executive/Poland, Romania, Russia

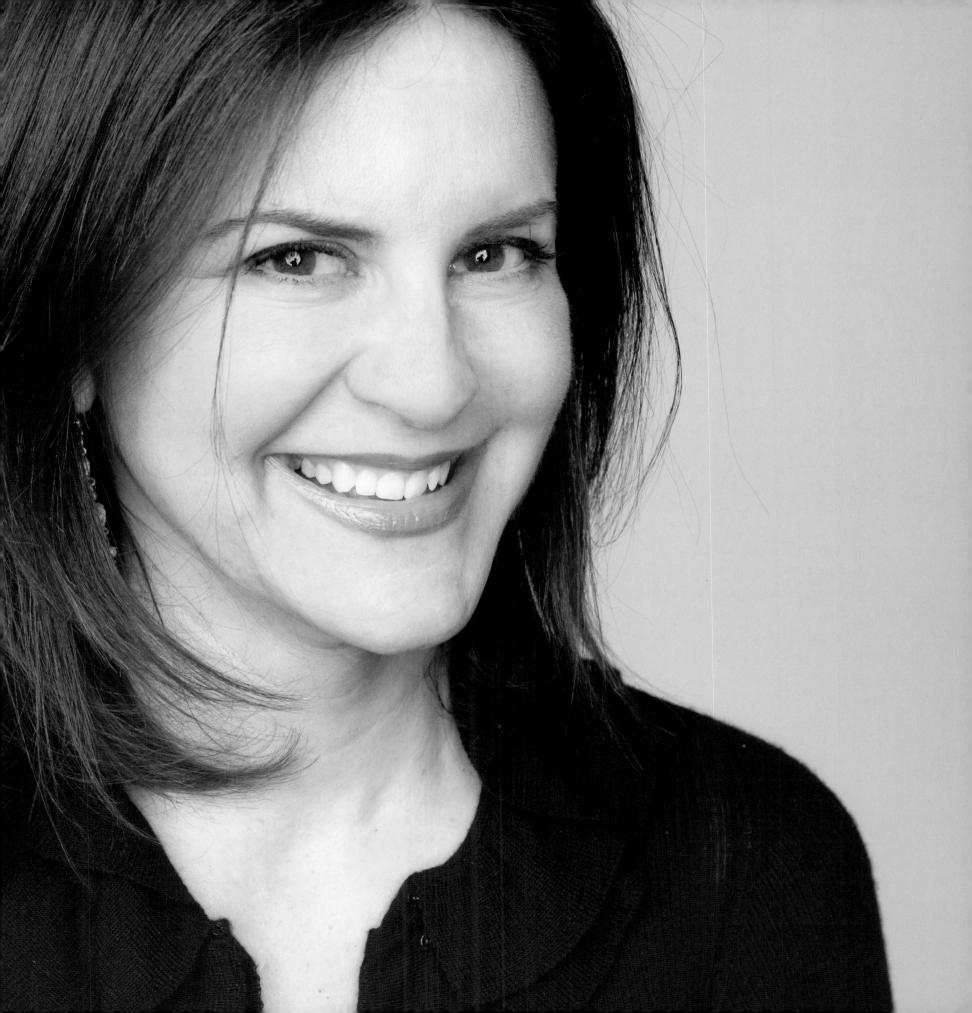

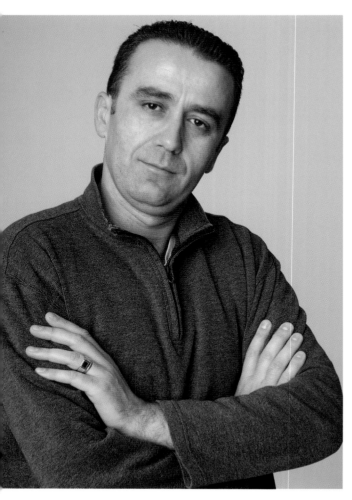
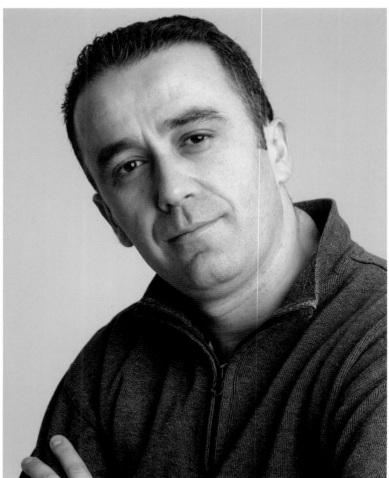

Our family can trace back many generations to the southern Adriatic country on the Mediterranean, Montenegro, but I arrived in America more recently, to escape the war-torn area of my homeland. America has given me the freedom to live and to work. My mother and brother are both in America now, and I also have an American son. When I became a citizen, it was one of the best days of my life. I am proud to call myself an American.

Haxhi "Jack" Djonbalic/Restaurant Worker/Albania, Montenegro

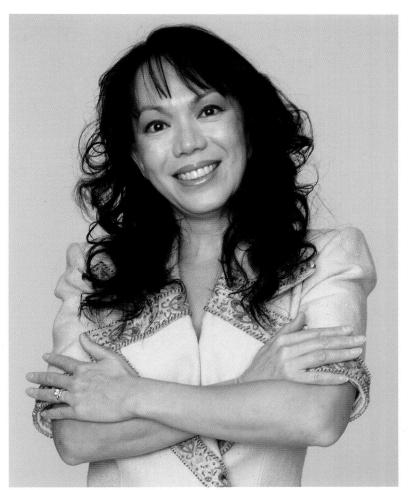
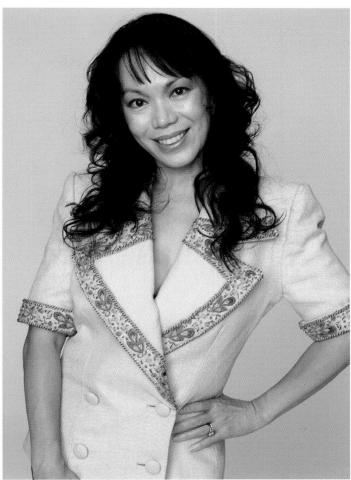

Rothman

My mother had two children and was pregnant with her third when Saigon was falling, and we escaped to Taiwan. We ultimately arrived in a refugee camp in Arkansas, but then lived in Pittsburgh and Boston. Today, my mother is still in Massachusetts, along with one of my brothers.

Tiffany Bui Rothman/School Psychologist, Performing Artist/Vietnam

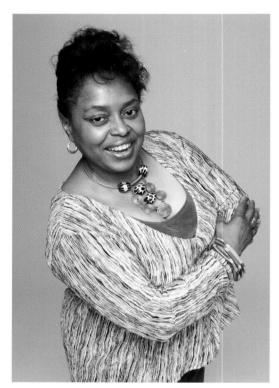 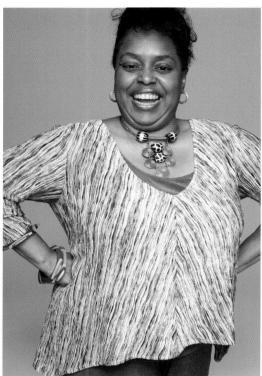

Through the oral tradition of my family, we know that we originally came from Sierra Leone to the Low Country of South Carolina. Transplanted African slaves kept a rich tradition of passing this information on to next generations. During our American journey, we also intermarried with both Cherokee and Shinnecock Indians. My father was born in South Carolina, but moved to Brooklyn, New York, where he met my mother. It was there that they stayed to raise their family. As an educator, part of my goal is to continue to carry on the oral traditions of my family history.

Linda M. Jackson/Educator/Cherokee, Sierra Leone

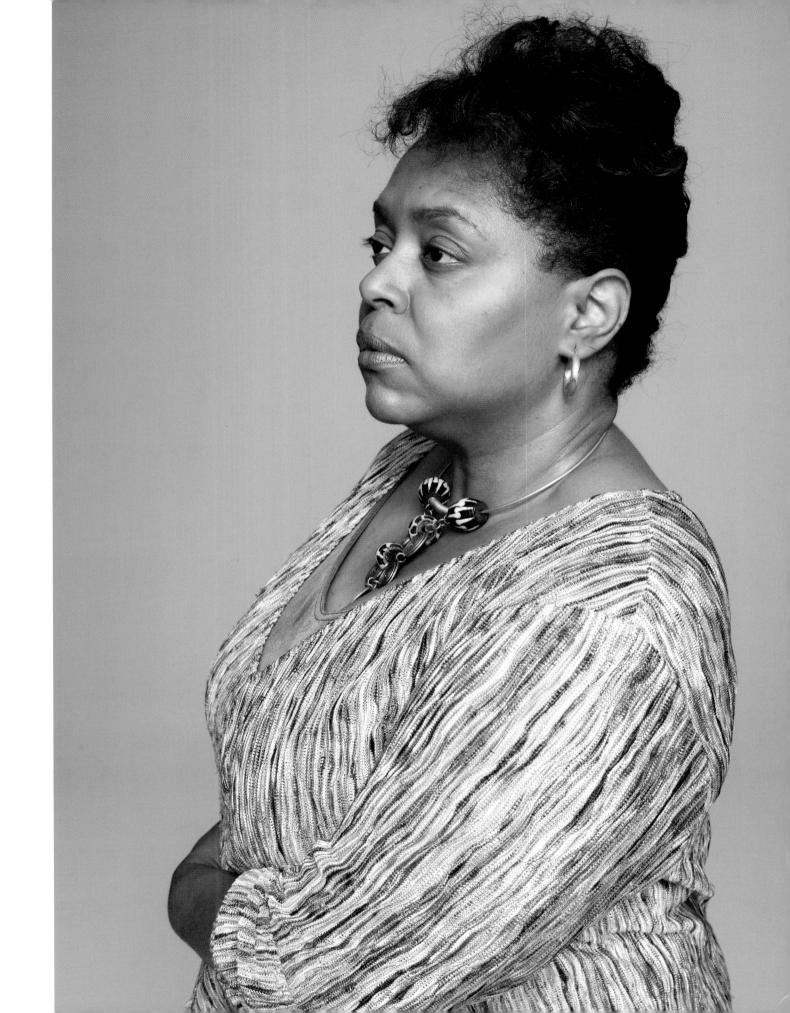

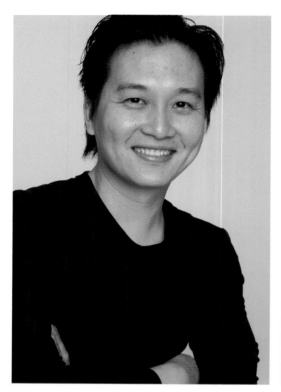 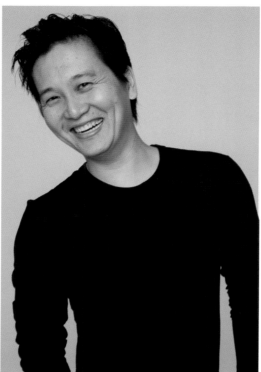

My own ethnic background is Burmese. As a first-generation American, I married an American who has German, Austrian, French and Polish blood, so our child now has five bloodlines, a mix of Asian and European. My half-brother has Japanese blood, so when we all get together, it's a real mix of American bloodlines.

Jonathan Lee/Teacher/Burma

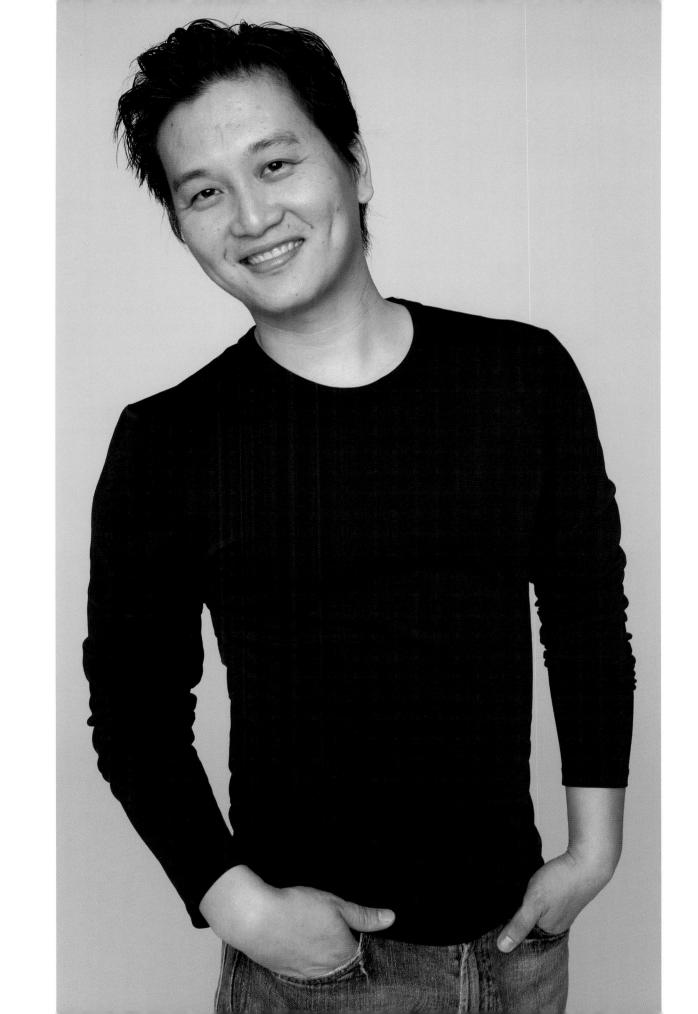

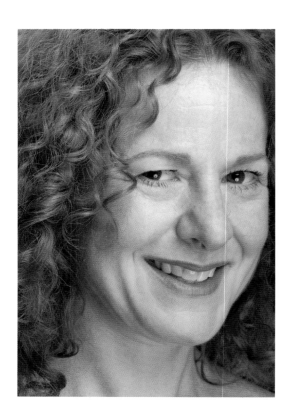

Seelig

All of my grandparents came from Eastern Europe, in search of a better life in America. My grandmother worked as a seamstress, my grandfather as a retailer, and one of my grandmothers ran a speakeasy, where she made her own moonshine! One of my grandfathers became an architect, which is the path that my father followed. My mother worked as a bond analyst on Wall Street. As a second-generation American, I've been able to absorb the best of all of their experiences to create my own American destiny.

Jill Seelig/Publisher/Belarus, Lativa, Lithuania, Ukraine

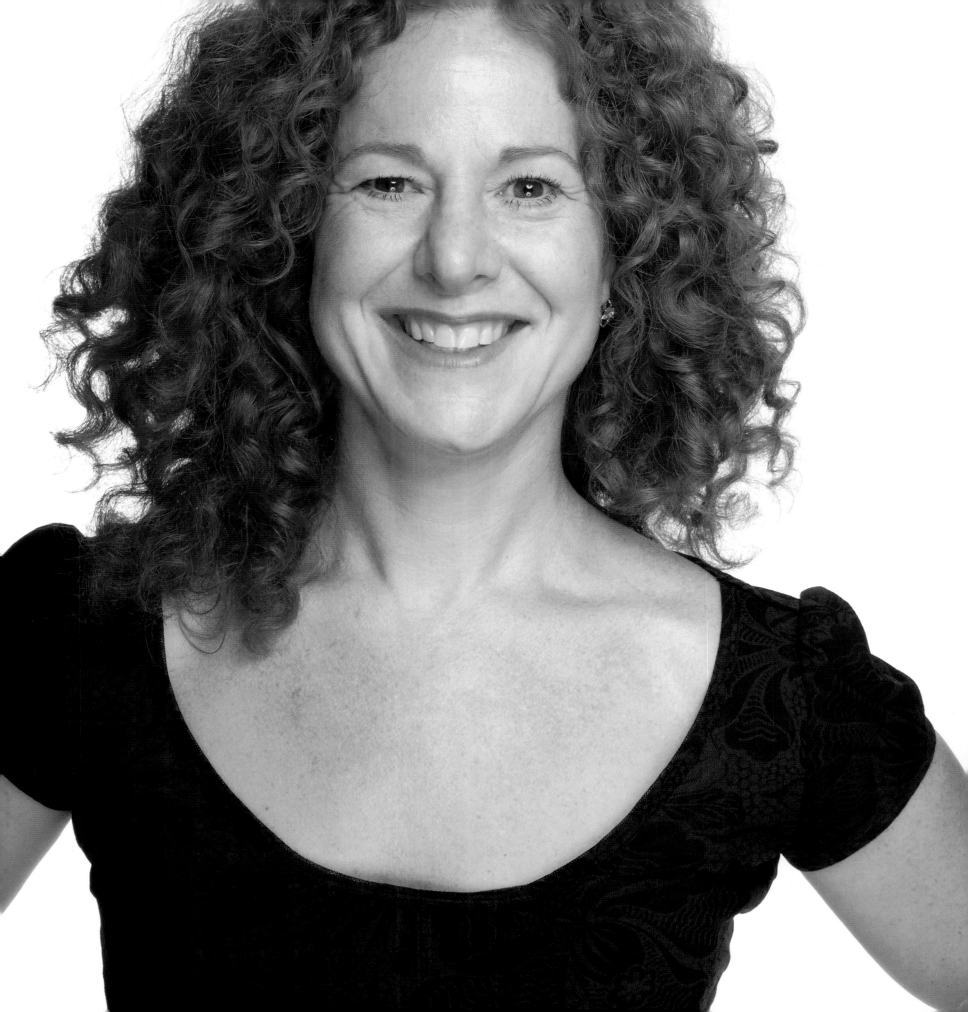

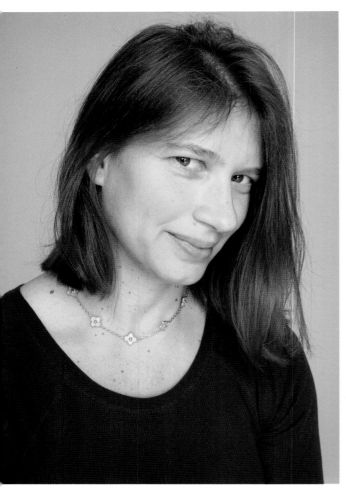 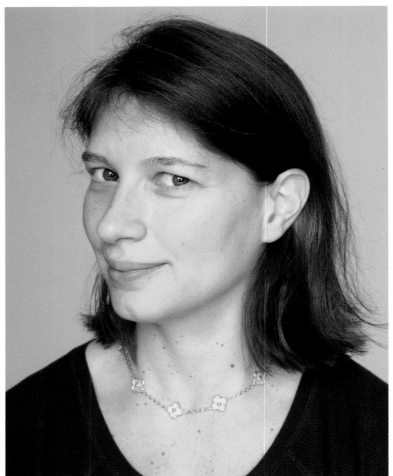

Manglis

My mother was an American, but my father was a Greek Cypriot, and I lived on Cyprus, until I came to the United States to attend college. While my mother's European background was fairly tame, my father's was filled with drama. One of my distant relatives was the ruler of the Cyprus states during the Ottoman Empire, but was beheaded for political reasons. Once I came to America, I decided to stay to raise my own family.

Katerina Manglis/Financial Consultant/Cyprus, England, Germany, Greece, Scotland

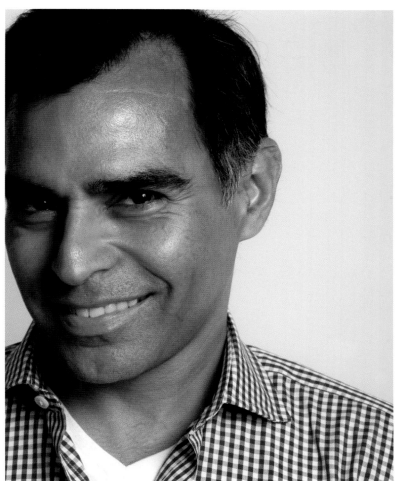
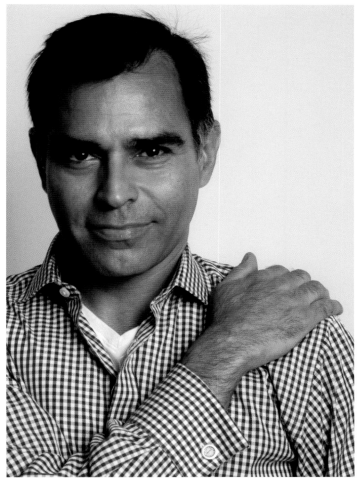

Alfonzo

My great grandparents migrated from Spain to Venezuela in the late 1800s. My father's brother had already moved to America and become a citizen. After I studied in Mexico, I was inspired by my American uncle to move first to Southern California and then to the East Coast. Now, I'm proud to be an American citizen myself, and plan to spend my life here.

Guillermo (Bill) Alfonzo/Fashion Executive/Spain, Venezuela

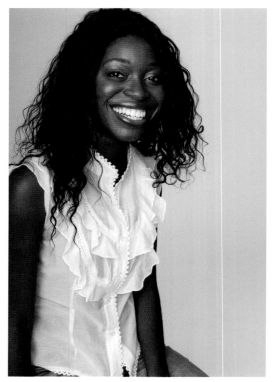 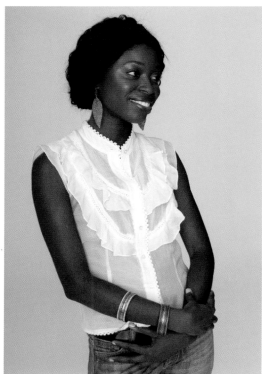

Thom

While I was born in Guyana, we first moved to Canada and then moved to America. My mother was the first person in our family to ever graduate from college—as a registered nurse—and I am carrying on her tradition, as the second person in the family to graduate from college. In 1999, I became a proud American citizen.

Keisha Thom/High School Special Education Teacher/Guyana

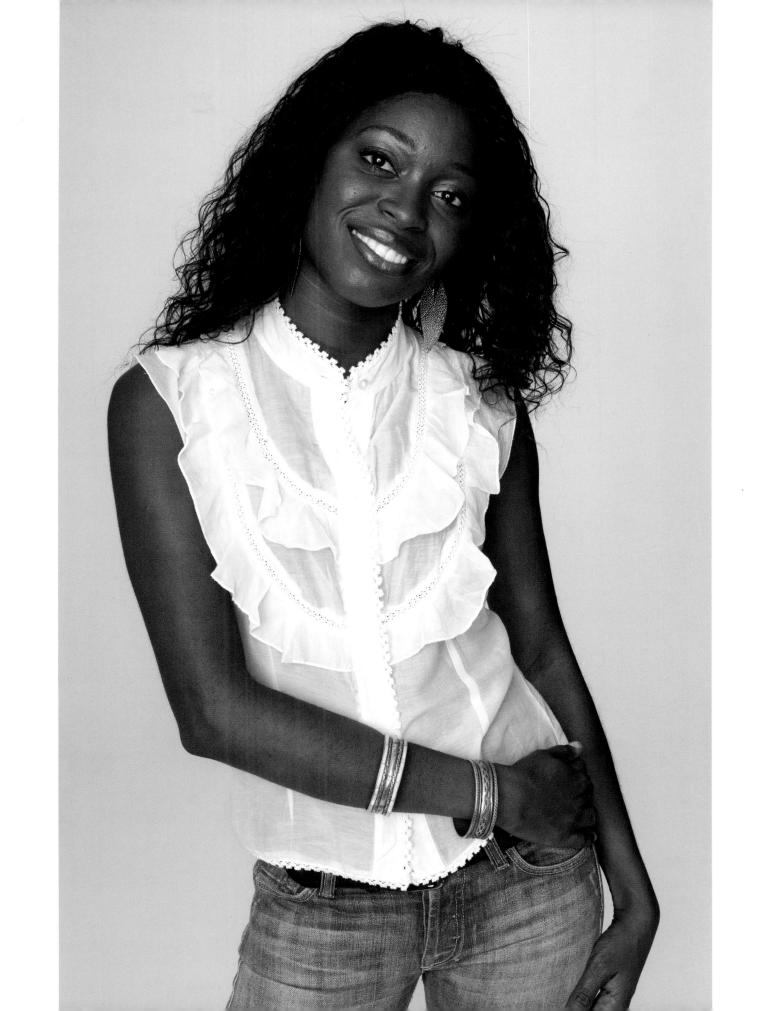

Acknowledgments

I'd like to thank my paternal grandparents, Louis Clinton and Christina O'Shea, who arrived in America from Ireland and England, respectively, and to my maternal great-grandparents, Frank Wenslovas and Michelina Malinowski, who came from Lithuania. Their actions set our family on our own American journey.

A special thank you to the very special Marta Hallett, whose encouragement is unwavering; to David Turner, an amazing photographer, who is both teacher and friend and was there every step of the way; and to Sarah Karp for her creative design. My personal thanks to Francine Crane, who spent hours of her own personal time in helping to make this project happen.

The list is too long to thank everyone who connected me to friends, family, and colleagues, in order for me to identify American citizens, who would all add up to one hundred countries of origin. But a special thank you has to go to Simon Rogers, who was an extraordinary support.

My family and friends cheered me on throughout the making of *American Portraits: 100 Countries*. For the tough moments, a thanks to Tom DeVincentis, who always pushed me forward. For checking in on my progress on a regular basis, I'm grateful to the talented artist Mary Rolland, who has taught me a lot about the creative process.

What I learned during the creation of this book were the fascinating and inspirational tales that make up the family histories of those people whom I met. A nation is a reflection of its people, and I am thankful to the millions that have come before me. We all have a responsibility to them to carry on the ideals of this special place that we call America.

Michael Clinton
New York, New York